Gilles Néret

Balthasar Klossowski de Rola
BALTHUS

1908–2001

The King of Cats

TASCHEN

KÖLN LONDON LOS ANGELES MADRID PARIS TOKYO

COVER:
The White Skirt (detail), 1937
Oil on canvas, 130 x 162 cm
Private collection
(Courtesy Thomas Ammann Fine Art, Zurich)

BACKCOVER:
Balthus photographed in 1933 by Man Ray

ILLUSTRATION PAGE 1:
Self-portrait, 1949
Oil on canvas, 116.8 x 81.2 cm
Private collection, Geneva

ILLUSTRATION PAGE 2:
Nude in Profile, 1973–1977
Oil on canvas, 225 x 200 cm
Private collection

BELOW:
Project for *Puss in Boots*, 1975–1976
Pencil on paper. Private collection

© 2003 TASCHEN GmbH
Hohenzollernring 53, D–50 672 Köln
www.taschen.com
© VG Bild-Kunst, Bonn 2003, for the works of Balthus
© Man Ray Trust, Paris / VG Bild-Kunst, Bonn 2003, for the work of Man Ray
Text and conception: Gilles Néret
Editing and images: Ines Dickmann, Cologne; Béa Rehders, Paris
Editorial coordination: Kathrin Murr, Cologne
Translation: Chris Miller, Oxford
Cover: Angelika Taschen, Cologne

Printed in Germany
ISBN 3-8228-2206-X

Contents

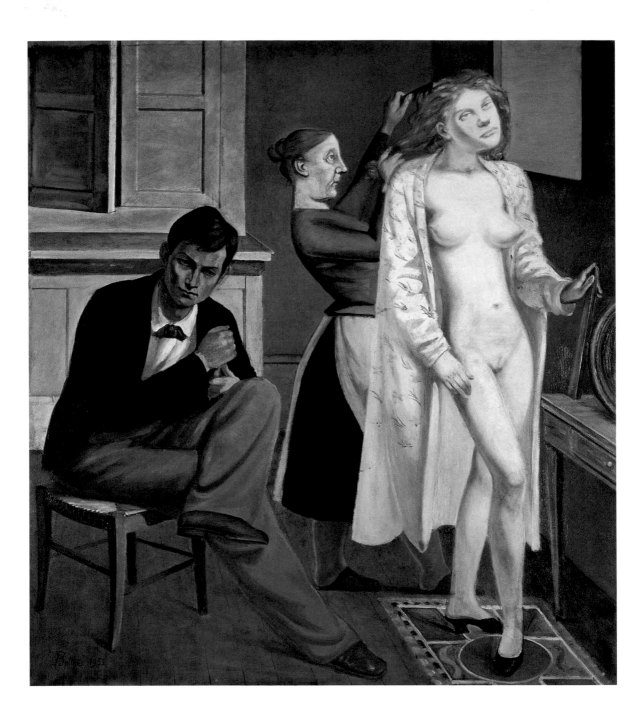

Reincarnating the Art of the Painting

"What a disappointment! All figurative!" For the casual visitor, Balthus's first solo show (at the galerie Pierre, Paris) must have come as quite a shock. 1934 was the high summer of abstraction and Surrealism, and Balthus's attempt to "reincarnate the art of painting" (as the poet Pierre-Jean Jouve put it) made him, from the outset, a marginal figure. At twenty-six, the tide was against him. His art was self-evidently founded in equal parts on imagination and a form of realism midway between the Quattrocento and the most extreme Classicism. In an article published in the *La Nouvelle Revue Française* in May 1934, Antonin Artaud took up the cudgels on behalf of Balthus's incongruous enterprise. "Painting has, it seems, wearied of depicting beasts and extracting embryos. It seeks to return to a sort of organic realism, which, far from fleeing the poetic, the marvellous and the fable, is more than ever bent on them. And now it possesses the means required. For there is surely something a little too facile about playing with incomplete or nascent forms in order to generate the unexpected, the extraordinary and the marvellous. It is not patterns one paints but existent things; one does not forestall the work of nature on the microscope slide merely to extract the inarticulate. The painter confident of his means and powers deliberately sets out into external space, takes possession of the objects, bodies and forms that he finds there, and makes more or less inspired play with them. Balthus paints primarily light and form. The light on a wall, a parquet, a chair, or an epidermis serves to invite us into the mystery of a body furnished with a sex clearly visible in its every asperity. The nude I am thinking of has something dry and hard about it; it is very exactly filled in. And there is also, it must be said, something cruel about it. It makes sex inviting, but does not disguise its dangers. As to poetry, it enters Balthus's painting in the form of a picture entitled *Cathy Dressing* (p. 6), in which the young, desirable body of a woman asserts its dream-like authority over a painting as realistic as Courbet's *Studio*. Imagine a painter's model suddenly transformed, in real life, into a sphinx, and you will have some idea of the impression made by this painting. A technique from the time of David is placed at the service of a violent, modern inspiration. And it is truly the inspiration of a unhealthy epoch, in which the artist who conspires with the real exploits it only in order to crucify it the better.' No better definition has ever been given of the singularity and modernity of Balthus. Nor did Balthus ever deviate from this path after that first exhibition at Pierre Loeb's

"Why have you that silk frock on, then?", 1933
Indian ink and pencil
Illustration for Emily Brontë's *Wuthering Heights*

PAGE 6:
Cathy Dressing, 1933
Oil on canvas, 165 x 150 cm
Paris, Musée National d'Art Moderne –
Centre Georges Pompidou

gallery. His work surprised and compelled in equal measure, its apparently impassible Neo-Classical technique placed at the service of often disturbing motifs. It is a powerful contrast. For his motifs are erotic – and provocatively so; the items Balthus exhibits within the Renaissance window of his paintings are his own obsessions.

Such eroticism had previously targeted the eye directly. In Balthus, its target was indirect: the brain. Marcel Duchamp had hinted at this new form of expression: "There is a difference between the kind of painting that addresses itself exclusively to the retina, and the kind that goes beyond the retina, for which the tube of paint is a mere springboard. The religious [painters] of the Renaissance were of the latter kind. The tube of paint held no interest for them. They simply wished to express their idea of divinity in one form or another… In my case, the goal is different; it is a combination, or a least, a form of expression that only grey matter can render." Duchamp's *credo* required that the shudder of excitement triggered by painting should now be "cerebral" rather than "retinal". Painting now had other purposes, in particular, shock-value, for a "a painting that does not shock is not worth the effort". Eroticism must therefore assume a new form. Duchamp concluded, "I have a lot of faith in eroticism, since it is really very general throughout the world; it is something people understand."

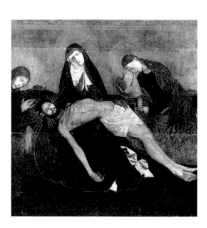

Detail of the *Villeneuve-lès-Avignons Pietà*, c. 1470
Paris, Musée du Louvre

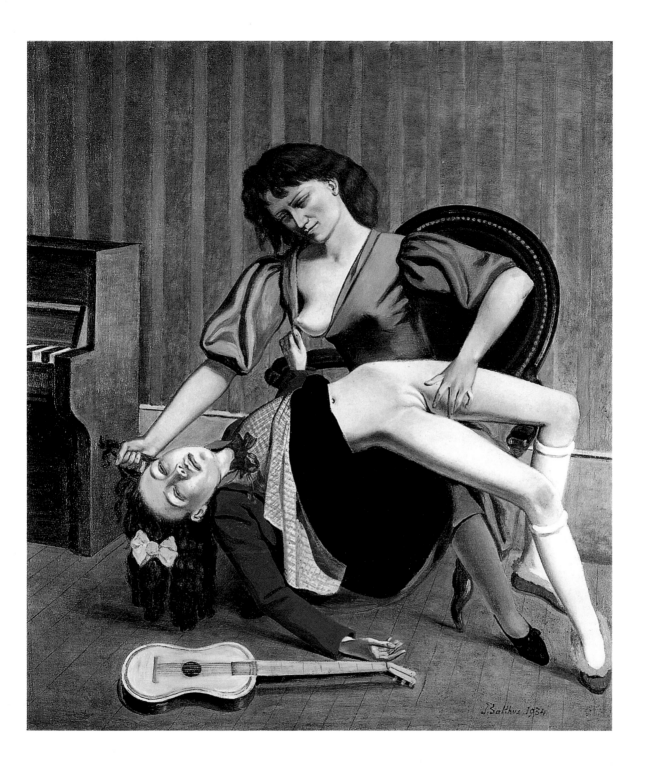

The Guitar Lesson, 1934
Oil on canvas, 161 x 138.5 cm
Private collection

The Street, 1933
Oil on canvas, 195 x 240 cm
New York, The Museum of Modern Art.
James Thrall Soby Bequest

Piero della Francesca: *The Legend
of the True Cross* (detail), after 1460
Fresco
Arezzo, San Francesco Church

Heinrich Hoffmann-Donner:
King Nutcracker and Poor Reinhold, 1851

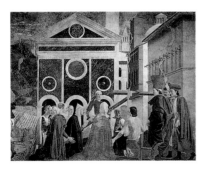

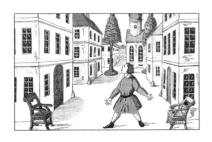

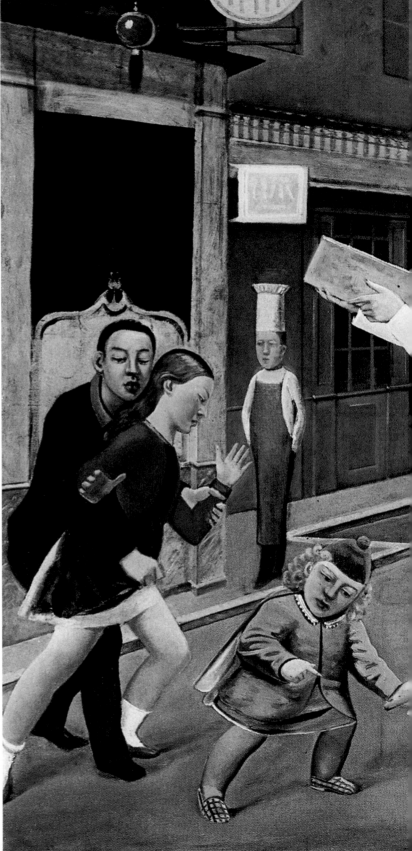

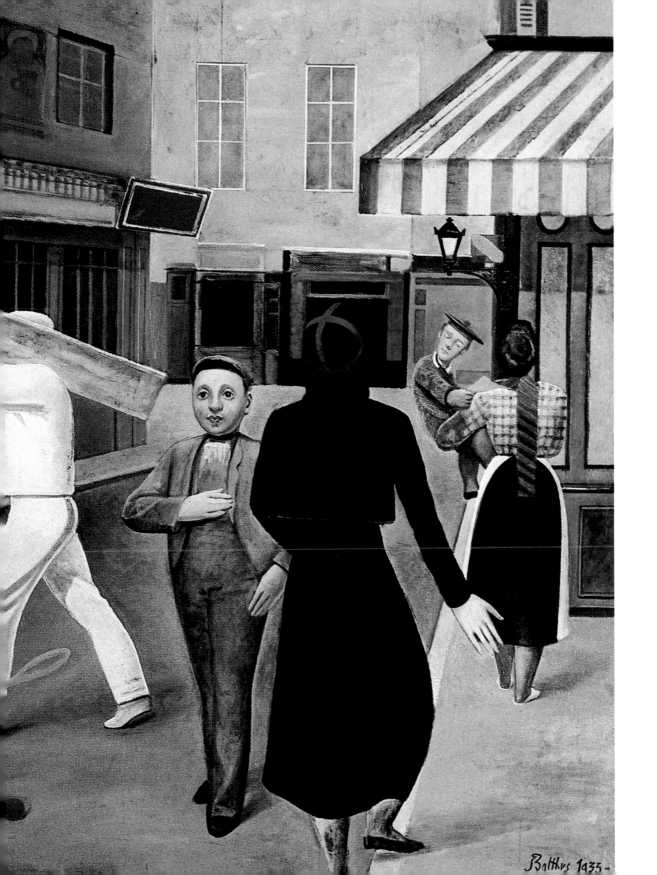

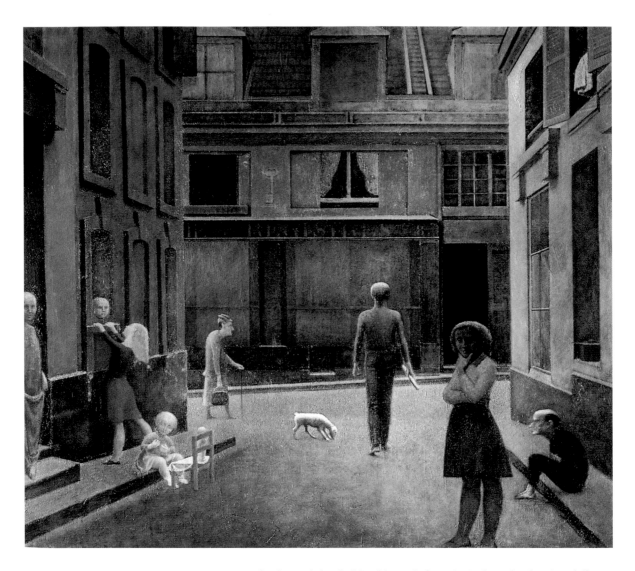

The Passage du Commerce-Saint-André,
1952–1954
Oil on canvas, 294 x 330 cm
Private collection

To shock people by clothing his erotic fantasies in the style of a Piero della Francesca fresco or a painting by Courbet (that other *provocateur*) was precisely Balthus's intention. And the paintings exhibited at the galerie Pierre were indeed, without exception, images of exacerbated desire: *Cathy Dressing* (p. 6), *Alice in the Mirror* (p. 50), and *The Guitar Lesson* (p. 9). *The Street* (pp. 10/11) combined rape and absurdity. The American collector who bought *The Street* in 1938 put on record the nuisance caused to him by "the naughty passage in question". First of all, at the customs station of Hartford, Connecticut, where he lived; it was allowed in after some hesitation, largely on the basis of his own reputation for eccentricity. Subsequently, when he hung it in his home; his neighbours complained that it was a bad example for the young, and it was eventually stored away in a trunk. And finally, when he attempted to donate it to the Museum of Modern Art, in New York, which refused to exhibit it. The composition of the painting was inspired by Piero's fresco *The Legend of the Holy Cross* (p. 10), which Balthus had copied in Italy, and by Heinrich Hoffmann's *King Nutcracker* (p. 10),

but the world it reflected was both absurd and erotic, as if seen "through the looking-glass". These somnambulistic pedestrians in rue Bourbon-Le-Château (a street in the Saint-Germain-des-Prés area of Paris) are not all of them very properly behaved. The girl on the left is, it seems, Alice herself, but this is no wonderland, and she suffers the attempted rape of Tweedledum. In the centre, his twin Tweedledee ostensibly looks straight ahead, but reaches out to grope the woman passing him. She in turn throws out an arm, perhaps in surprise, perhaps to take a swing at the culprit. Tweedledee's gesture proved very influential on the young men of Farmington, where the picture was hung. They, too, could reach passing women. In desperation the owner eventually begged Balthus to retouch the gesture, and, to his surprise, the artist consented. The "corrected" painting was returned some years later, in 1955, with a little note: "I used to like shocking people, but now it bores me…"

Not all of Balthus's subsequent career bears this out. But twenty years later, when he painted a new version of *The Street* in *Passage du Commerce-Saint-André* (p. 12), the aggressive eroticism had vanished. The bizarre still has its place in the painting. But the painter disdainfully exits the magic circle, stalking off with a golden *baguette* in his hand. Is it, as the French word implies, his wand?

The White Skirt, 1937
Oil on canvas, 130 x 162 cm
Private collection

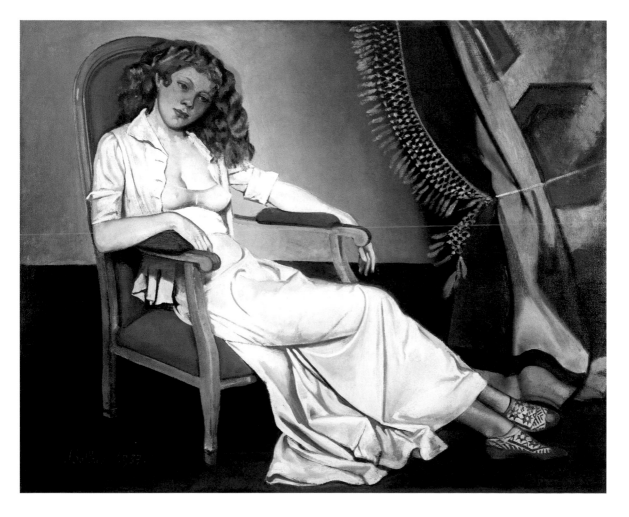

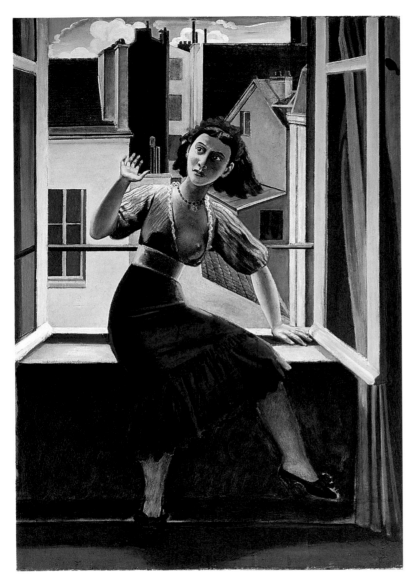

LEFT:
The Window, 1933
Oil on canvas, 161 x 110.7 cm
Bloomington (IN), Indiana
University Art Museum

RIGHT:
Elsa Henriquez, photo, 1933

Cathy Dressing (p. 6) was inspired by Emily Brontë's novel *Wuthering Heights*, for which Balthus had just made a series of pen and Indian ink drawings that no one wanted to publish. Other paintings, such as the *Blanchard Children* (p. 18), which finished up in Picasso's collection, were also inspired by these illustrations. The original illustration (p. 7) was largely innocuous; it showed Cathy smoothing the folds of her dress while the servant, Nelly, arranges her hair, and Heathcliff asks whether she is going anywhere, and if she is not, "Why have you that silly frock on, then?" For the painting, Balthus completely changed the atmosphere, infusing it with a scalding eroticism. (He refers, incidentally, to a "silk frock".) That frock has become a dressing gown open to reveal Cathy's naked body, her pointed breasts and bare pubis slightly averted from the spectator's gaze. Balthus and his future wife, Antoinette de Watteville, were the models. The

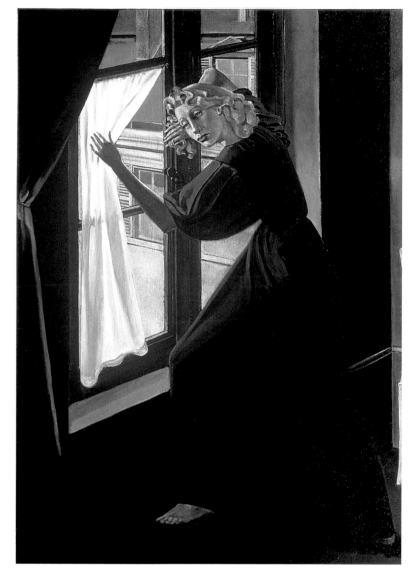

new scene seems to depict an unspecified erotic rite, a beautiful woman being groomed for some mysterious sacrifice. Aggressive sexuality was a feature of the exhibition. When Artaud spoke of a sex "visible in its every asperity", he was not exaggerating; the sex in question belonged to *Alice in the Mirror* (p. 50), and was painted in relief. The culminating point of the spectacle was *The Guitar Lesson* (p. 9). In 1934, it was presented in a separate room; fifty years later, in 1984, it was excluded from the Balthus retrospective at the Centre Georges Pompidou and the Museum of Modern Art, New York. The exhibition curator, Dominique Bozo, incensed by this, regretted its absence in his catalogue article. This was motivated, he said, "by considerations that we do not entirely share, but which show that, fifty years after it was painted, Balthus's work has lost none of its extraordinary power to disturb". After its appearance in the Pierre gallery in 1934,

LEFT:
Lady Abdy, 1935
Oil on canvas, 186 x 140 cm
Private collection

RIGHT:
Lady Abdy in *Les Cenci*, adaptation
by Antonin Artaud from Shelley and
Stendhal, set and costumes by Balthus.
Photo: Lipnitzki-Viollet, 1935

15

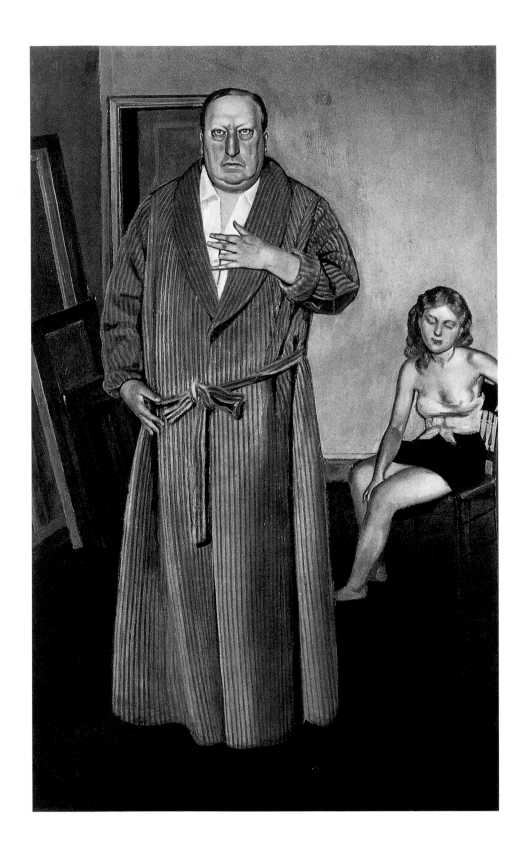

16

Joan Miró and his Daughter Dolores, 1937–1938
Oil on canvas, 130.2 x 88.9 cm
New York, Museum of Modern Art. Abby
Aldrich Rockefeller Fund

it was not again seen in public till 1977, when it was shown at the Pierre Matisse gallery in New York. Constrained by Anglo-Saxon Puritanism, Tom Hess, writing in *New York* magazine, confined himself to an exhaustive description, adding "I insist on *The Guitar Lesson* though it cannot, due to the intensity of the image, illustrate the pages of this magazine. Balthus considered the painting initiatory, and no doubt intended it to be seen 'in secret, by a few privileged [spectators]'. It may have been a mistake to expose it so soon to the masses. It has, at all events, recently undergone a transformation that 'forces the painter to keep it from the public'. It will have to await more tolerant times. Yet it seemed to me when, quite recently, I saw the work again, that this highly-charged image, sustained by its exceptional pictorial mastery, was clearly one of the great classics of the

PAGE 16:
Portrait of André Derain, 1936
Oil on canvas, 112.7 x 72.4 cm
New York, The Museum of Modern Art.
Acquired trough the Lillie P. Bliss Bequest

PAGE 18/19:
The Mountain, 1937
Oil on canvas, 248.9 x 365.8 cm
New York, The Metropolitan Museum of Art.
Purchase, Gifts of Mr. and Mrs. Nate B. Spingold
and Nathan Cummings, Rogers Fund and
The Alfred N. Punnet Endowment Fund,
by exchange, and Harris Brisbane Dick Fund

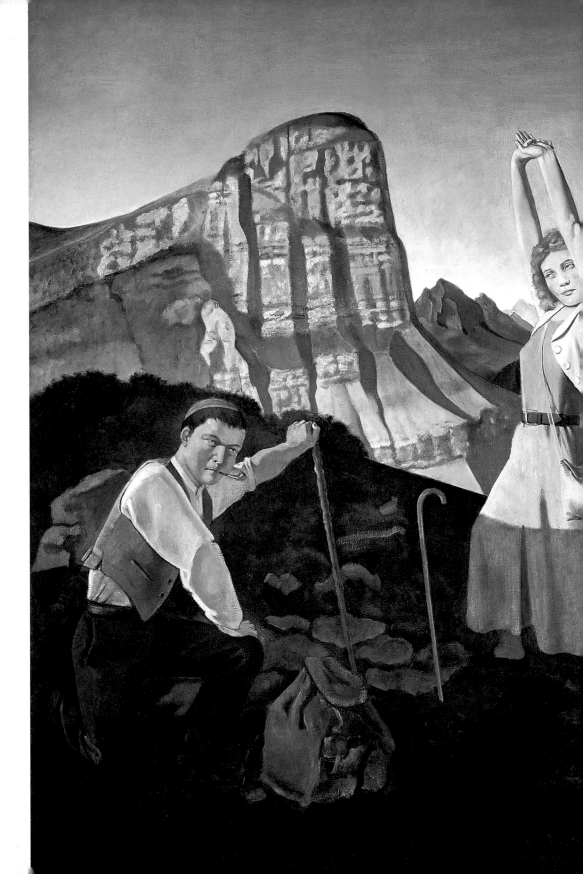

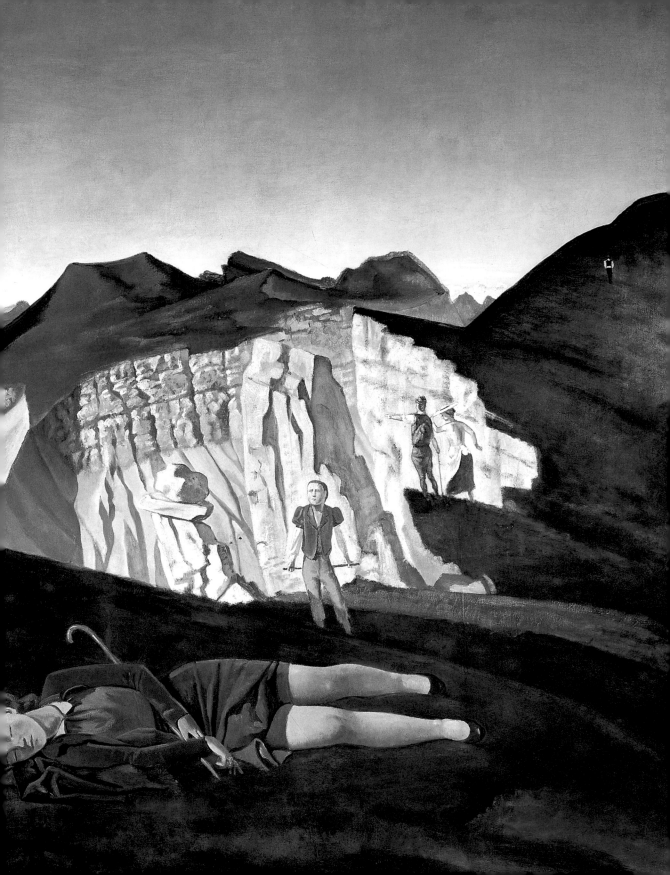

The Blanchard Children, 1937
Oil on canvas, 125 x 130 cm
Paris, Musée du Louvre, Picasso Donation,
deposit Musée Picasso, Paris

Georges de la Tour: *The Cardsharp* (detail),
c. 1630
Paris, Musée du Louvre

20th century. It is with great sadness that we resign ourselves to its absence here".
Fortunately *The Guitar Lesson* reappeared in 2001 at the Balthus retrospective
in the Palazzo Grassi in Venice. This "great classic of the 20th century" was self-
evidently inspired by one of the most intensely religious images in Western
painting, the *Villeneuve-les-Avignons Pietà* (1470, p. 8, in the Louvre). Balthus
happily confessed that his principle object in painting *The Guitar Lesson* was
to acquire a sulphurous reputation. Seated by the piano, a woman holds an ado-
lescent girl bent back over her lap. The girl's pinafore dress been lifted to the
navel, exposing her legs and pre-pubescent sex. With one hand, the woman pulls
a pigtail as if twisting a guitar-pegs, with the other she strums on its "strings"
of thigh, crotch and labia. The "victim" lies in the position of the *Villeneuve-
les-Avignons* Christ. Smooth-bodied as the discarded guitar, she reaches up to
pinch her teacher's exposed nipple. This gesture also has a source, the famous
Fontainbleau-School painting of *Gabrielle d'Estrées and One of Her Sisters*
(c. 1594). It shows the sisters bathing; one reaches to pinch the other's nipple in
illustration of the erotic sport and charming lesbianism of François Premier's
court.

What should we make of the ruttish figures that Balthus thus stages in *Cathy
Dressing*, *Street*, *Alice in the Mirror* or *The Guitar Lesson*? Are they real? Or are
they puppets, dolls and automata? The theme of sexual puppetry was wide-
spread at the time. Between 1911 and 1934, Duchamp played numerous variations
on coitus between the mechanical and the human. Bellmer's *Puppet Games* date
from 1934. And there is the curious case of Kokoschka, who lived from 1918–1922
with a life-size doll which he eventually "murdered". We might also cite Schlem-

mer's *Triadic Ballet*. Balthus, exasperated by the attacks on his subject-matter, spoke of a "sacred" eroticism. Jean Clair concurred: "To give sexual pleasure and contribute one's own is the horizon within which, in paradisiac fusion, flesh opens itself to infinite knowledge both of God and of a return to the blessed original fusion. Childhood, Paradise, and the paradise of childhood delineate this rediscovered horizon of grace – *Unschuld* – without which no painting is possible."

Balthus always sought to paint for posterity. The last brushstroke sealed for ever the action that he had staged. To attain this definitive harmony, a stillness resistant to the passing centuries, he worked long and hard on the materials of his painting, hand-making them according to the prescriptions of the painters of the Quattrocento. His model was, of course, Piero della Francesca's cycle of frescoes in Arezzo. He also expressed his admiration for Poussin, Courbet and Derain. In short, his was a scholarly painting, intended directly for the museum. Seeming to recapitulate the tradition of European post-Renaissance painting, it was, nonetheless, modern. But its modernity was personal, secret, obsessive. Balthus's elder brother, Pierre Klossowski, illustrated his own novels, the graphic work reflecting his writing as if in an infinite sequence of mirrors. Balthus was similarly monomaniac. Most of his compositions were constructed with microscopic attention to detail. Nothing was left to chance. It is as if, before putting brush to canvas, the artist had first composed a *tableau vivant*, a private spectacle

The Game of Cards, 1948–1950
Oil on canvas, 140 x 194 cm
Madrid, Museo Thyssen-Bornemisza

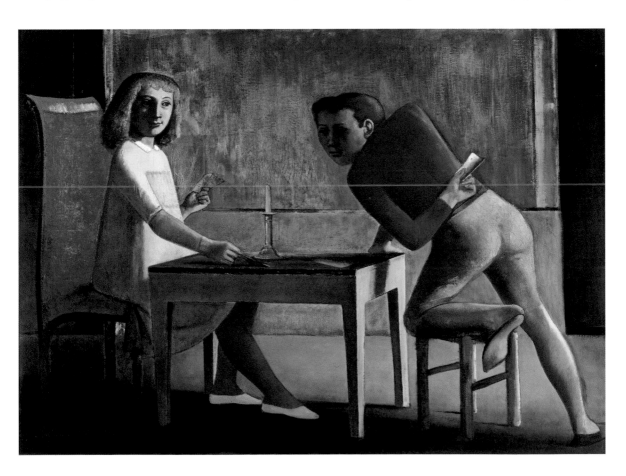

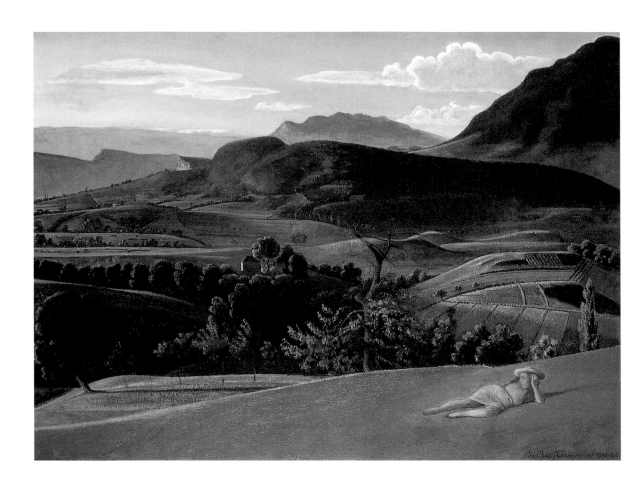

Champrovent Landscape, 1942–1945
Oil on canvas, 96 x 130 cm
Private collection

made for his own eyes only. The painting's function was thus to capture his obsession on canvas, to sublimate it by his artistry, to give it a definitive form in the cultivated language of a craftsman who worked for nothing less than eternity. His art's capacity to disturb does not, however, depend solely on the nature of his fantasies. Balthus had, from the outset, excelled at striking equally bizarre notes in his portraits; he contrived to suggest that his depictions were at best euphemistic, and that the truth, were it revealed, would be either terrifying or depressing. Of course, whenever he portrays women, it is immediately clear from attitude, pose and gesture that Balthus belongs to the painterly line of voyeurs that includes Boucher and Ingres, Degas, Toulouse-Lautrec and Bonnard.

But Balthus's realism has also received the more honorable epithet "magic". The most eminent writers have meditated on his work, from Rainer Maria Rilke and André Gide to Antonin Artaud, André Breton and Albert Camus. They were unanimous in acknowledging a very specific genius. Artaud admired the way Balthus had eliminated the "nascent forms" of Surrealism, while Surrealists such as Breton admired his surreptitious eroticism. Camus, by contrast, called him – with some justification – the Bluebeard of painting. In 1948, while working on the costumes and scenery for Camus's play *L'État de Siège* at the Théâtre Marigny, Balthus was never seen without his flock of young models.

He referred to them as his "nieces" or "angels"; they would sit around his feet like kittens, calmly exhibiting their designer underwear. They were the leitmotiv of his *œuvre*. René Char, another poet to succumb to these painterly temptations, confessed "We all desire the caress of that matutinal wasp known to the bees as 'young girl', in whose bodice is concealed the key to Balthus". Delvaux's wastelands are populated with somnambulistic women. Balthus preferred the slightly perverse acidity of adolescent girls who, in the purest Sado-Baudelairian tradition, are "now victim, now torturer".

"The only credible portraits are those in which there is little of the subject and a great deal of the artist", remarked that connoisseur Oscar Wilde. The female body, disintegrated by Cubism, disfigured by Surrealism and pulverised by Abstraction, regained, in this reversion to figuration, its original centre-stage role. A projection of the artist's desires, it acquired the form closest to his heart, becoming omnipresent. Its carnality is twofold, now innocent young girl, now *femme fatale*, and sometimes a little of both... Paul Valéry observed: "What love was to narrative and poetry, the nude was to art". The artist projects himself into his works; if he is successful, his spectators do the same. The phenomenon ceases to be one of intimacy, becoming a collective event in which the spectator can,

Larchant, 1939
Oil on canvas, 130 x 162 cm
Private collection

like Renoir, declare "Faced with a masterpiece, I simply enjoy". It would, however, be simplistic and even naïve to rehearse the oft-made comparison between Balthus's "angels" and the nymphets popularised by Nabokov in his famous novel *Lolita*. Nabokov describes the fear, confusion, anguish and delight of a forty-year-old who has fallen under the spell of a fourteen-year-old. True, there are Lolitas depicted in paint, but they vary with the artists who paint them. Specific to Balthus, Dix, Schiele and Heckel is their obsession with the world of adolescence: with those moments of hesitation and madness experienced by every adolescent faced with a world in which the rules have been set by the adults, and where authenticity and risk are attainable only by setting those rules aside. The mystery of the budding sexual maturity of the young girl-woman is not the only thing that fascinates these artists. They also portray the terrible grandeur of all solitude, and particularly that of childish solitude. They represent the world that surrounds the lonely child, a universe coated in the grey of the child's majestic boredom. The young girls they depict lie open to every desire in their hermetic world, which is now a melancholy, cruel paradise, now a hell of imprisonment and secrecy. And there, for the pleasure of painter and spectator alike, they indulge their every fantasy, their girlish turpitude and exhibitionism, displaying a bare, pre-pubertal sex like *Alice in the Mirror* (p. 50) or an expanse of knickers, like *Thérèse Dreaming* (p. 33) and *Young Girl with a Cat* (p. 34). Waiting for their companion to bestow the decisive caress, as in *The Guitar Lesson* (p. 9), they slip a less than innocent hand under their own skirts. Here is

Landscape with Trees (The Triangular Field), 1955
Oil on canvas, 114 x 162 cm
Private collection

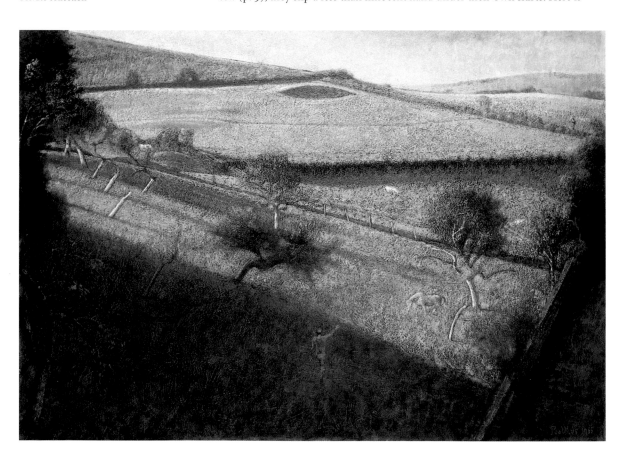

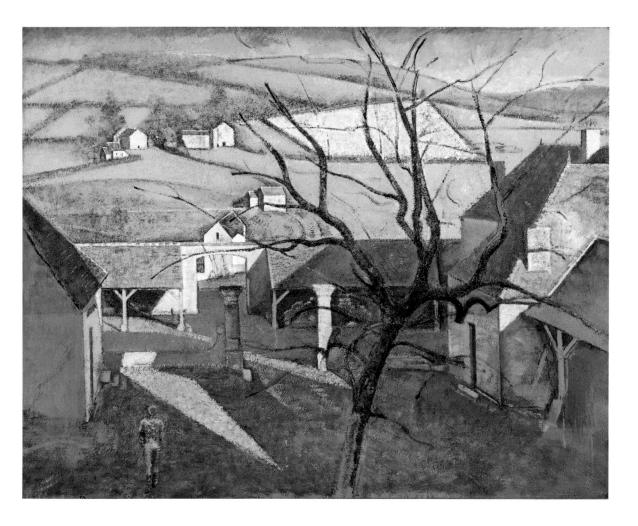

Farmyard at Chassy, 1960
Oil on canvas, 130 x 62 cm
Paris, Musée National d'Art Moderne –
Centre Georges Pompidou

Delacroix in 1854: "It is not the thing itself that must be done, but the semblance of the thing, and it is not for the eye but for the mind that this effect must be produced".

One thing is clear. Though he claimed to be influenced by Courbet, Balthus avoided overt stylistic reference. This is a function of his style. Bathed in dense, almost tangible light, his painting is distinguished by vivid draughtsmanship and a sense of drama. His figures are arranged just so: those dreamy young adolescent girls, exiled in their hermetic chambers, are surprised in the intimate postures they adopt only in the certainty of solitude. Consequently critics have tended to reduce Balthus's work to a form of traditional figuration somehow distorted for his own scabrous purposes. Which is a mistake, for there is always more to Balthus than this. Like Rembrandt, like Picasso, the more he loved his model, the more he wanted to exhibit her to the entire world. Thus Antoinette de Watteville, his wife, who modelled for *The White Skirt* (p. 13), refused to remove her bra for the sitting: "I didn't want my breasts exhibited in a museum", she said later. The transparency of the bra that Balthus therefore painted was the more suggestive, and contributed to the success of the composition: a subtle harmony of cream, ivory, pink and white, contrasting and col-

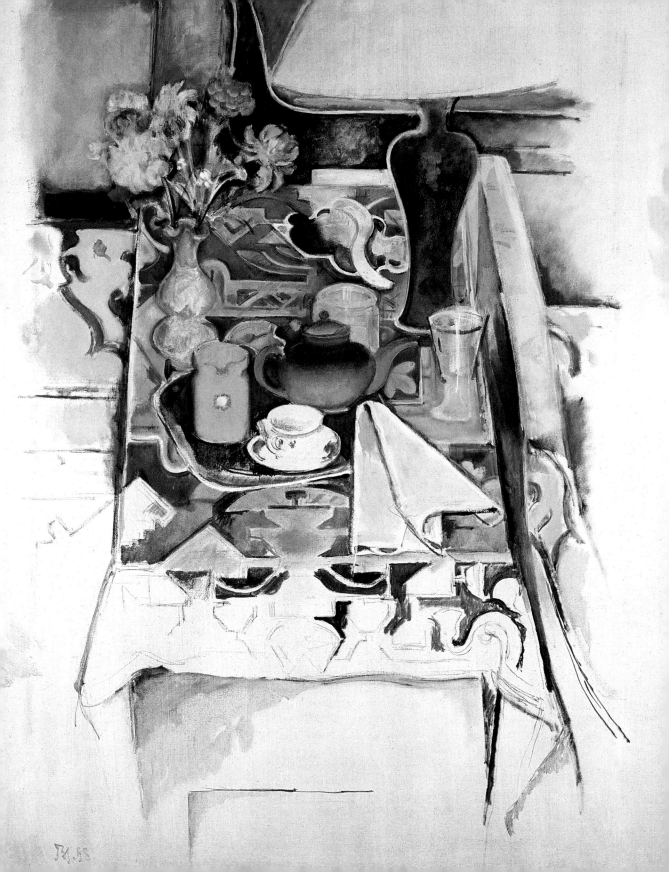

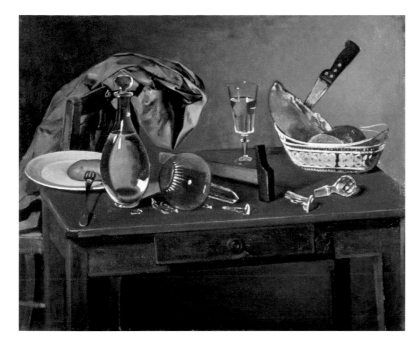

Still-life, 1937
Oil on wood, 81 x 99 cm
Hartford (CT), The Wadsworth Atheneum
Museum of Art. The Ella Gallup Sumner and
Mary Catlin Sumner Collection Fund

lating skin and fabric. The spirit of Courbet seems to preside over Balthus's homage to Antoinette.

Paul Valéry warned the Paris of the Roaring Twenties: "We civilisations know that we are mortal". And it is true that people tend to think of the inter-war period only in terms of its avant-gardes. To do this is to forget that period witnessed a worldwide surge in violent nationalism, whose official representation was forms of monumental realism placed at the service of the State. Everywhere artists sought not to liquidate tradition but to wrap themselves in it as in a banner. From Hopper (the United States) to Diego Rivera (Mexico), artists came to Europe to learn the lessons not of Impressionism but of Manet and Courbet. It was not the avant-gardes that interested them, but the painting of the Quattrocento, and Piero della Francesca in particular. In Italy, the *Valori Plastici* movement had reacted against the iconoclasm of the Futurists, while in Germany, painters such as Dix and Schad had broken away from Expressionism and returned to the old "German" masters, from Dürer to Holbein. In France, Lhote and Derain promoted what they called the "return to order", and the words "contemporary realism" were often heard, though on the lips of detractors they had a pejorative connotation; those who were against the avant-garde were reactionaries. Paul Valéry, who described himself as the "Bossuet of the Third Republic", himself argued for this "return to order" in the catalogue of the exhibition *Italian Art from Cimabue to Tiepolo*. The show had been sent to Paris by Mussolini, and its appearance in 1935 at the Petit-Palais made a considerable splash. "The absurd superstition of the new – which has, alas, replaced our ancient and excellent faith in the judgement of posterity – harnesses effort to the most illusory of goals and applies them to the creation of what is, by its very nature, ephemeral: the sensation of the new. All values are vitiated by the artifice of publicity, which subjects them to fluctuations almost as violent as those daily recorded on the Stock Market. What could be simpler

PAGE 26:
Still-life with Lamp, 1958
Oil on canvas, 162 x 130 cm
Marseilles, Musée Cantini

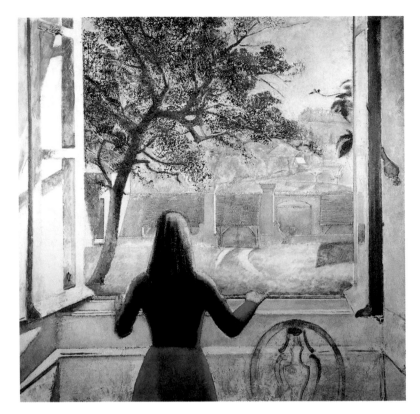

in its goal and surer in its effect than a portrait by… Raphael? Yet we wander
from theory to theory… There is a strange contrast between what we require
today of runner, a tennis-player or an athlete who seeks to distinguish himself…
and the little required for an artist to make his reputation." This was a slippery
slope, and led, alas to Hitler's threatening observation, "There are still painters
who see things otherwise than as they are", or to Stalin, who now wanted, he said,
a culture that was "proletarian in content and national in its form". "Realism"
thus became tribute-money rendered unto Caesar, and the distortion was such
that, after the Second World War, the avant-gardes became synonymous with
resistance to barbarity, and figurative painting was again disgraced. Indeed, the
famous critic Herbert Read, who published his *Concise History of Modern Paint-
ing* in the 1940s, excluded all reference to figurative contemporary art from his
study. It was, he thought, by its very nature, shameful and defeatist.

This gives an idea of the violent ostracism long endured by figuration, though
Balthus's aristocratic reserve had never concerned itself with either politics or
fashion. Giacometti, another friend, having escaped a different form of over-
weening authority, that of André Breton, told Balthus in 1934: "… the day I found
myself on the pavement, again determined to reproduce human faces as faith-
fully as possible, like some beginner at the [académie de la] Grande-Chaumière,
I felt happy and free…" To the critics who accused him of retrograde realism,
Balthus replied "The real isn't what you think you see. A painter can be a realist
of the unreal and a figurative of the invisible". And, marked by his obsession
with erotic themes drawn directly from the unconscious, he added, in a further
evasion, an ironic smile on his lips: "I do Surrealism in the style of Courbet".

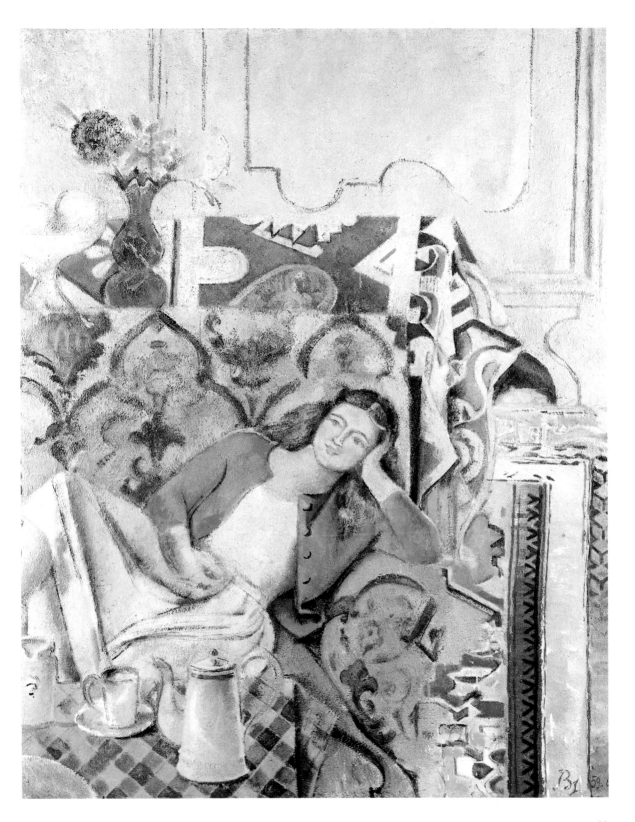

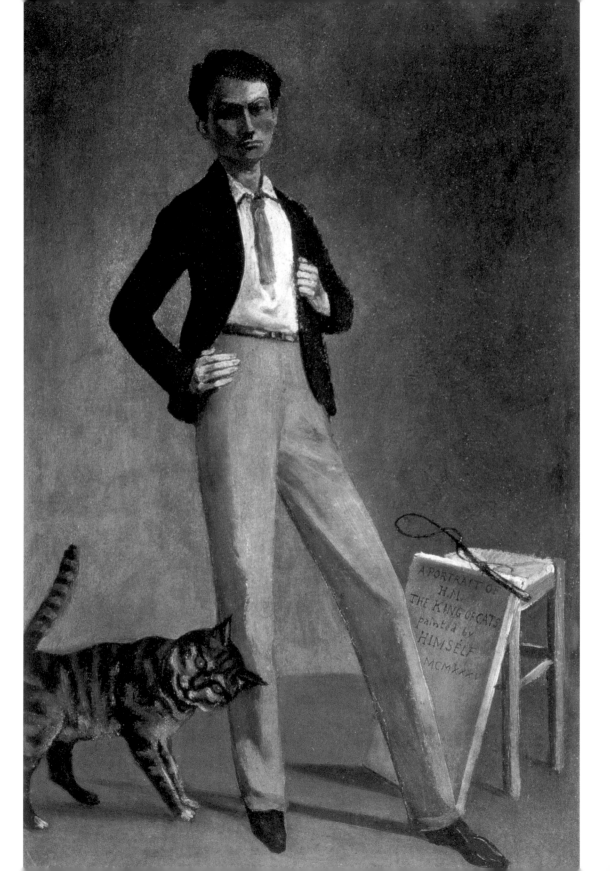

The King of Cats

In 1967, the Tate Gallery held a Balthus exhibition and asked the painter to supply biographical material for the catalogue. He replied by telegram: "No biographical details. Begin: Balthus is a painter of whom nothing is known. Now let us look at the pictures". He might equally have suggested: begin with my picture *The King of Cats* (p. 30). Or: reread the preface written by Rainer Maria Rilke. The celebrated German poet had been a friend of Baladine and the young Balthus; he wrote the preface for the first drawings that the artist published, a series of images in memory of Balthus's cat *Mitsou*. "Who knows cats? Do you *really* think you know them? I confess that, for my part, I have always considered their existence a very far-fetched notion… For if animals are to belong to our world, they must, surely, enter into it some little? They have to assent, however little, to our life style, they have to tolerate it; otherwise, hostile or fearful, they will simply perceive the gap that divides us, and that will be how they relate to us… Was man ever their contemporary? I doubt it. And I can assure you that, at dusk, my neighbour's cat at times jumps right over my body as if it were uninhabited, as if to prove to the flabbergasted world of objects that I have no real existence." Balthus might also have suggested that the Tate quote a few lines from Baudelaire. They are more evocative than any prosaic biographical detail:

Francisco Goya y Lucientes: *A Choleric Man*, 1797–1798
Madrid, Museo del Prado

> In my head there pad the feet
> Of a handsome cat, at home in his chambers
> Strolling, sturdy, charming, and sweet.
> The sound of his mewling is barely heard,
>
> He is the familiar spirit here.
> He judges, decides and inspires
> All that transpires: my self his empire.
> A fairy cat? Or God in cat's attire?

And when, as Balthus suggests, we look at the paintings, from *Mitsou* and the self portrait *The King of Cats* (p. 30) to the restaurant-sign *The Méditerranée's Cat*, we see that the painter is clearly feline; indeed, he boasts of the fact, and claims to have been a cat since childhood. As Claude Roy, a close friend, noted: "Little cats don't go to school. Their parents teach them all that they need to

PAGE 30:
The King of Cats, 1935
Oil on canvas, 71 x 48 cm
Private collection

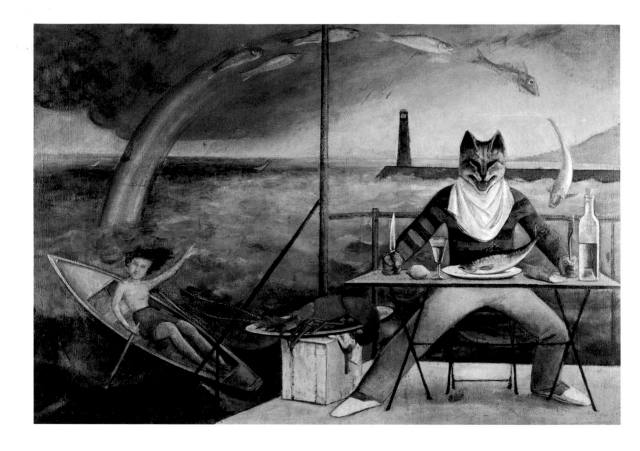

The Méditerranée's Cat, 1949
Oil on canvas, 127 x 185 cm
Private collection

PAGE 33:
Thérèse Dreaming, 1938
Oil on canvas, 150.5 x 130.2 cm
New York, The Metropolitan Museum of Art.
Jacques and Natasha Gelman Collection

know: hunting, running, and stretching. Balthus's father, a painter and art historian, his mother, also a painter, and his family friends all bestowed on the young kitten every trick they knew. Cats are self-taught. They don't enrol at the School of Fine Arts. They study, they observe, they learn and experiment all by themselves." And these family friends were not just anyone. They included Bonnard and Derain. Derain's bewitching remark, "The only purpose of painting today is the recovery of lost secrets," profoundly marked the young Balthus. As for Bonnard, he was, says Balthus "still a young man when I met him. I remember having dinner at his table when I was twelve. Matisse was there too, and he said 'Bonnard, you and I are the greatest painters of our era'. And Bonnard replied with his usual zest 'That's terrible. If you and I are the greatest painters, I feel like weeping'. Bonnard told my parents not to send me to a painting school. In this, he was at one with the spirit of the time. So my parents refused to send me to school. In any case, the teachers there were not very good. I'm self-taught. I learnt by making copies in the Louvre, above all copies of Poussin. Then I went to Italy because of my father. He always said that Piero della Francesca was the Cézanne of his period. I still remember the sensation of inexplicable beauty I felt before those frescoes". And Balthus goes on to cite his friend Picasso, who, throughout his life, was inspired by past masters to do "otherwise than they did". "He often used to say: 'Picasso paints nothing but Delacroix, what a great painter!' I think that the artist has a duty to be profoundly 'narcissistic', that is, he has a duty to love beauty from the heart."

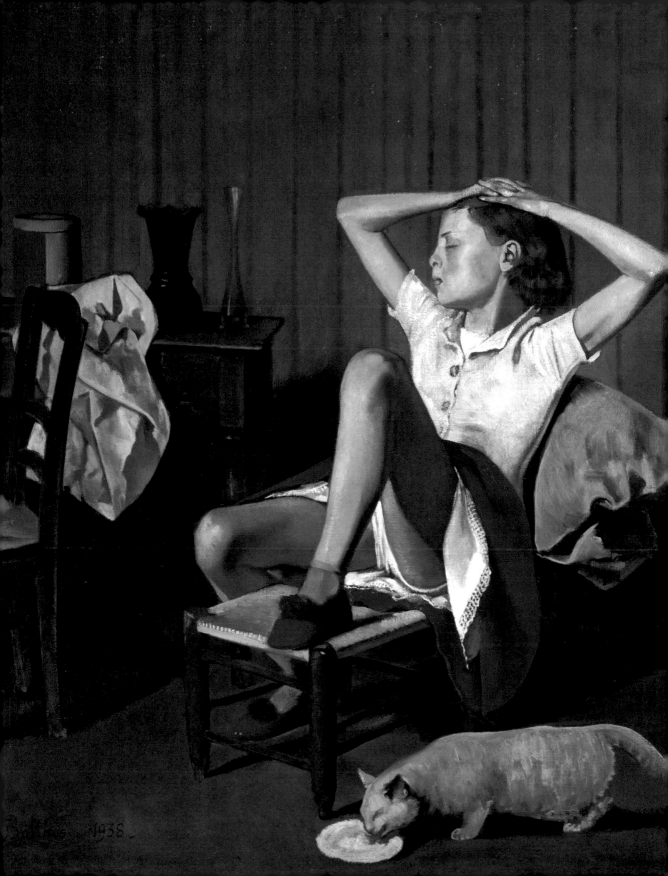

Man Ray: Photocollage, 1935

It was in memory of a dinner with Picasso at Golfe-Juan in 1947, when they ate grilled fish and shared a bottle of white, that Balthus two years later painted the sign *The Méditerranée's Cat* (p. 32) for a Parisian seafood restaurant in the place de l'Odéon. Feline he might be, but Balthus was also born under the sign of Pisces, and the self-portrait brings these two aspects together. Land, sea, rainbow, the little girl waving from her skiff, the fish, and the cat's bestial appetite, these things summarise Balthus' imaginary universe – as if the painting were a children's story like *Alice in Wonderland*. This Balthus read very early on, and it marked him profoundly: "I have always known Alice. I have always loved Alice," he said of the first book that he read. But why does the young girl in the series *Cat in the Mirror I, II* and *III* (pp. 44, 47 and 48) hold up a mirror to the cat? Balthus smiled ironically when the question was put to him. "The cat is stunned by the image in the mirror. It's a polemical picture, I wanted to make fun of people who write on painting". A cat is unapproachable to those it rejects; one cannot look into the soul of these "friends of knowledge and pleasure" who "seek the silence and horror of the shadows". They "take up noble attitudes as they dream, great sphinxes stretched out in the depths of the desert fastness, who return, it seems, when they sleep, to a single endless dream". Thus Baudelaire. "Cats are cats, and that's all there is to it, their world is the world of cats through and through", Rilke wrote in his preface to *Mitsou* (1920). "They look at us, you think? But can one ever be certain they deign, even for a moment, to sully their retinas with our futile image? Perhaps, when they stare at us, they merely confront us with a magical exclusion from the invariable repletion of their pupils? True, certain of us feel the influence of their wheedling and electric caress. But they remember, too, the strange and abrupt fits of distraction with which the dear animal abruptly puts an end to such seemingly mutual effusion. Privileged and accepted as they are by cats, they have frequently been rejected and disowned, and, while yet cradling the mysterious apathetic beast to their heart, are brought up short on the threshold of

Advertisement for Pear's Soap, 1901

PAGE 34:
Girl with a Cat, 1937
Oil on wood, 87.6 x 77.7 cm
Private collection

35

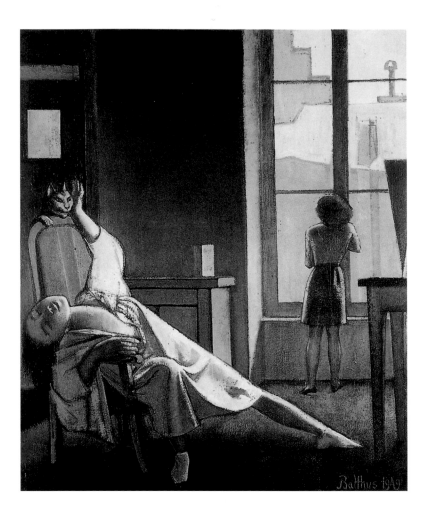

the cat-world, which only cats inhabit, surrounded by circumstances at which we cannot guess."

Discreet from the first, the King of Cats came into this world on 29 February 1908, a leap year. Given the "public absence of this rare and discreet anniversary", his friend Rilke wished him happy birthday whenever they met. Discreet, not to say secretive, Balthus remained. A dandy, aristocrat, and even, in his own terms, "suzerain lord", Balthus was happy to maintain a façade of opacity, just occasionally offering a clue to his enigmatic visions. "I've managed to remain anonymous. Ego and personality are not perhaps the same thing, but I prefer anonymity. I see adolescent girls as a symbol. I shall never be able to paint a woman. The beauty of adolescence is more interesting. The future is incarnate in adolescence. A woman has already found her place in the world, an *adolescente* has not. The body of a woman is already complete. The mystery has disappeared." Now Bluebeard, now Scheherazade, the King of Cats spins his stories out in painting after painting. At fourteen, he confided to a friend "I should like to remain a child forever". He perhaps thought, like Baudelaire, that "genius is just childhood rediscovered at will". Later, he confessed to a "happy childhood", and often repeated in old age "The best way not to succumb to second child-

The Week with Four Thursdays, 1949
Oil on canvas, 97.7 x 83.8 cm
Poughkeepsie (NY), The Frances Lehman Loeb
Art Center, Vassar College

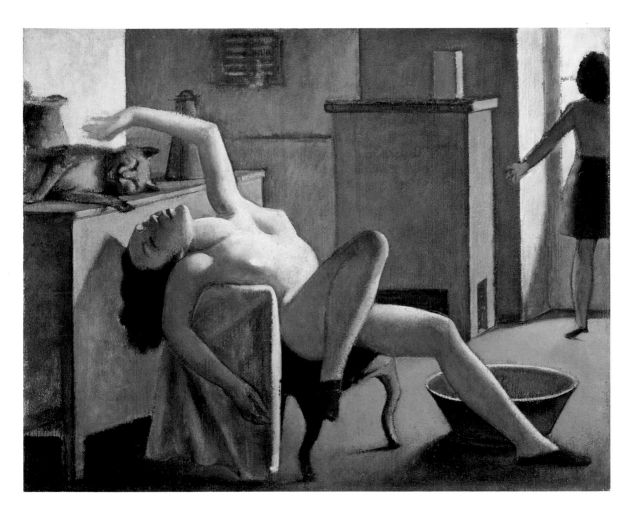

hood is never to have left the first". *Thérèse Dreaming* and *Young Girl with a Cat* (pp. 33 and 34) are fairy tales of *Alice in Wonderland* kind. The Cheshire cat, whose smile remains after his disappearance, watches over these young girls and their raised skirts. Alain Vircondelet, in his book *Balthus' Cats*, writes: "The uncovering of these thighs, under the control of the painter, and the barely disguised form of the sex reveal a secret geography that tends toward the unspeakable. The opening that bisects the meeting of the thighs is like the breach through which one passes to the other side of the mirror. The cat knows this; he stares at spectator and painter alike. A strange spell pervades mind and gaze, Baudelaire's 'angel of the bizarre' brushes the painting with his wings, and the spectator is left perplexed, mid-way between doubt and stupefaction."

Balthus lifts the veil a little more when he says: "My ideal would be to make religious paintings without a religious subject. I should like to render the beauty of the divine. Only Mozart has contrived to do so." Scandal was undoubtedly the objective of his *Guitar Lesson* (p. 9): "It was the only way to attract attention, but I'm glad now that this picture is considered simply as a painting. The theme is just a pretext." And the posture Balthus chose could, we have seen, shape the pitiful body of Christ just as it did the Lolita-guitar of his fantasy. "Like the Irish,"

Nude with a Cat (Nude with Basin), 1948–1950
Oil on canvas, 65 x 80 cm
Melbourne (Australia), National Gallery of Victoria. Felton Bequest

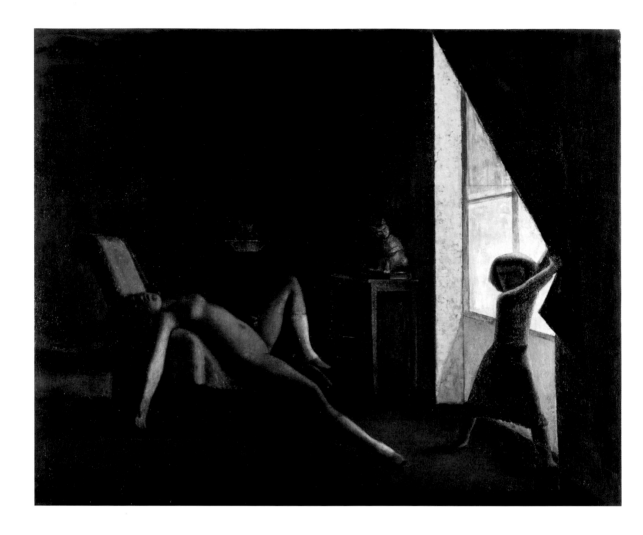

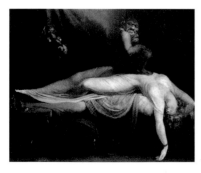

Henry Fuseli: *The Nightmare*, 1781
Detroit (MI), Detroit Institute of Art

Balthus observed, "I'm very Catholic. I have a profound belief in prayer… Prayer is a way of escaping from the self. I am not God, but I am probably a part of Him, and when I pray, I attempt to reach the light, to raise myself up. When I paint, it's like prayer." Shortly before Balthus's death, Richard Gere, the film star and adept of Buddhism, visited the chalet at Rossinière and asked him: "Who is he, the man who prays in paint and attempts to reach the light?" Balthus, at eighty, replied at once: "God. Man cannot create, he can only invent. The painter prays to him who creates, but they are alike. In the last analysis, the issue is this: who creates the creator? This is an infinite regress. The painter attempting to escape from himself grows closer to his creator. When one paints, one attempts to forget one's ego and that is the moment when I feel the light that is God, and my mind and my hands are nothing but machinery, machinery that listens. One listens for what one must do."

But Mozart is not the only artist to have rendered the "beauty of the divine". And of the many who aspired, some succeeded. Balthus might have cited Michelangelo, who was perhaps even closer to his own aspiration: "Love, burn, for whoever dies has no other wings with which to reach Paradise", wrote

Michelangelo in one of his poems, those songs of "ardent, rock-strewn lava". For Michelangelo, human beauty as it emerges from the divine hand – and as he represented it – was a reflection of celestial beauty, and bound therefore, when contemplated, to restore the soul to the divine. Thus it was, in his eyes, a work of piety to dress the Saviour in the "beauteous vestment of his nudity". What Balthus did for his adolescent models, Alice, Cathy, Katia or Michelina, Michelangelo did for his *David* or the *Ignudi* with which he liberally studded the corners of the Sixtine Chapel cornices. These he portrays as no less a prey to earthly passion than their maker. It is a dangerous proceeding. One cannot contemplate human beauty with impunity; one cannot contemplate the handsome *ephebos* or beautiful adolescent without risking the tortures of desire. Seeking to win his

PAGE 38:
The Room, 1952–1954
Oil on canvas, 270.5 x 335 cm
Private collection

Patience, 1954–1955
Oil on canvas, 90 x 88 cm
Private collection

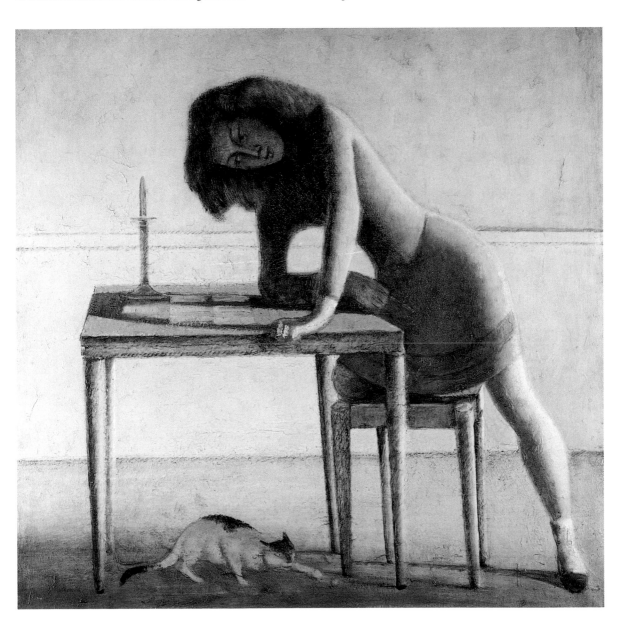

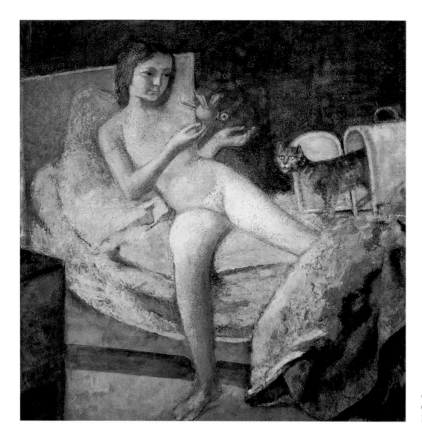

Getting Up, 1975–1978
Oil on canvas, 169 x 159.5 cm
Private collection

way to Paradise, Michelangelo perceived such torture as both desirable and inevitable. Giorgio Vasari says as much: "The idea of this extraordinary man was to compose everything in terms of the human body and its perfect proportions, in the prodigious diversity of its attitudes and moreover in the full range of its passionate inclinations and raptures of the soul". But Michelangelo loved those wingless angels, the limber young models of his *Ignudi*, while Balthus's eye was drawn to young girls in transition, budding or blossoming, and their hesitant, questing gestures. There is no masterpiece in the history of art that does not blend earthly with spiritual life: sex, eroticism and God. The rest is ornament.

In 1952, inspired by Henry Fuseli's *Nightmare* (p. 38), Balthus painted one of his most famous pictures, *The Room* (p. 38). In this painting, as in *Nude with a Cat* (p. 37), Balthus-the-cat surveys the scene from a distance, like some baleful owl. It is one of his most erotic pictures: a narcissistic adolescent girl such as he loved to depict is revealed in all her nakedness, her spread legs and sex exposed to the sun's caress by a malicious gnome who raises a drape like a guillotine. Like his model, Fuseli's *Nightmare*, *The Room* loses nothing of its ambiguity and mystery to scrutiny. Interpretation is left to the imagination and fantasy of the spectator. The pleasure of the erotic, in Balthus, is allusive. It takes interrogative form. It is enclosed within the weighty paradise of the artist's sensuality, and Balthus merely draws aside the curtains to let us see through the window the spectacle of his young girls falling victim to their own sensuality. These hermetically closed spaces isolate without protecting those who lie abandoned within their walls. The burden of desire and pleasure seems heavy beyond endurance.

PAGE 41:
Nude with Arms Raised, 1951
Oil on canvas, 150.5 x 82 cm
Current whereabouts unknown

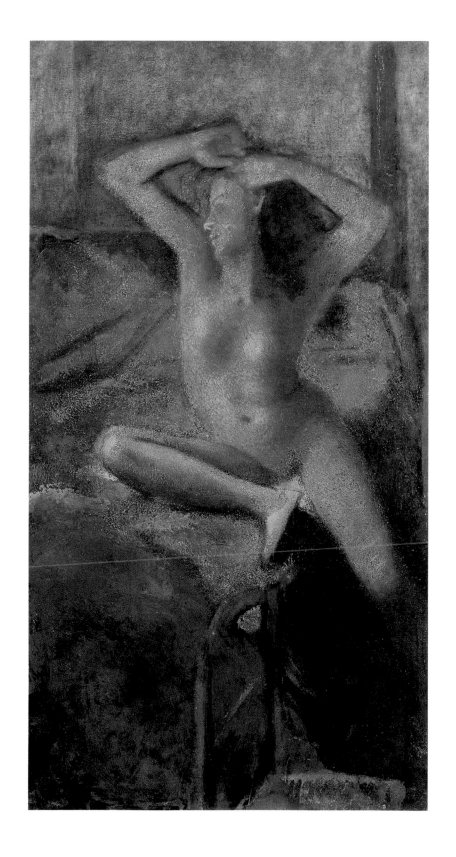

In their acceptance of the painter's visual homage, these young girls make generous gift of their bodies. They offer to the gaze what they have been strictly adjured above all else to conceal, what must never be glimpsed but always, without fail, be protected. They brave the most fearsome of our taboos, they show "all they've got". Which is why Balthus, and not he alone, was so obsessed by what lay beneath the skirt, by thighs drawn wide apart. There are few torments greater than that of the invisible, and there is a peace in seeing. Henry Miller, in *Tropic of Cancer*, tells how, lying at the feet of a woman on a park bench, he "saw everything", and invaded by a sense of peace, fell asleep on the spot.

The world of childhood is also one of games, in particular that of the puppet theatre. With *The Game of Cards* (p. 21) – no doubt the most cruel and disturbing of Balthus's works – *Patience* (p. 39), *The Living Room* and *Three Sisters* (pp. 42 and 43), we are again in the presence of games. The creatures on stage are monstrous, deformed, alarming and incomplete. Fresh from the chrysalis, they have not attained their perfected form. Antonin Artaud spotted this from the start: "With his angular, strangulated draughtsmanship and his earthquake colours, Balthus – who has always painted hydrocephalous figures with scrawny legs and long feet (proof that he himself finds his head a heavy burden) – when he has finished the distillation of his technique will show

The Living Room II, 1942
Oil on canvas, 114.8 x 146.9 cm
New York, The Museum of Modern Art.
Estate of John Hay Whitney

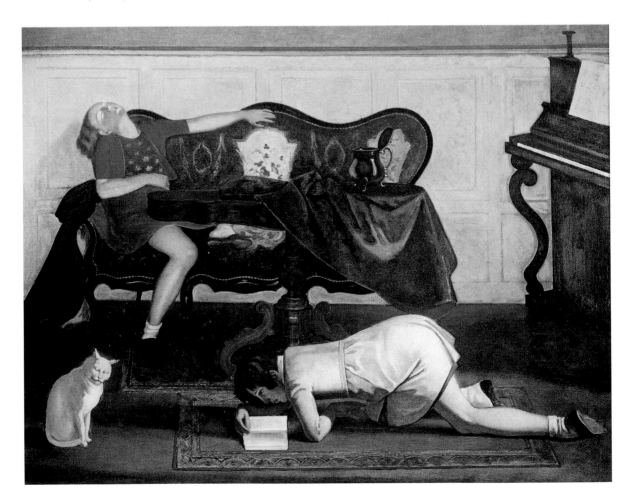

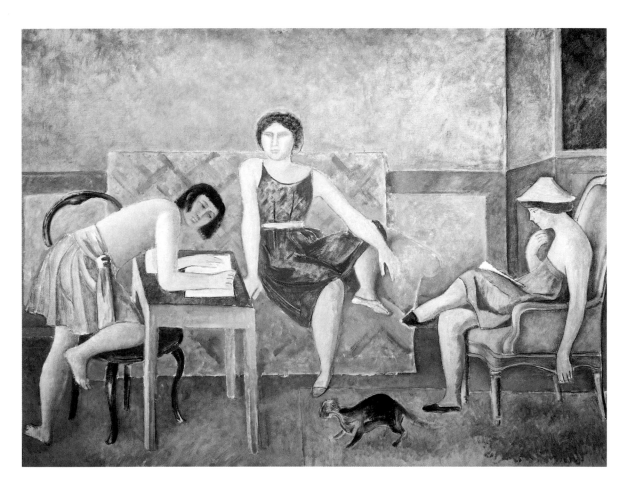

himself the Paolo Uccello or Piero della Francesca of our time. Or, better still, an El Greco who has somehow strayed into our era." The grimacing monsters and deformed dwarves of fairy tale have always afforded children great shudders of delicious fear. Jean Clair, in "The Hundred Years' Sleep" (his introduction to the *catalogue raisonné*), speaks of Balthus's protagonists as ill "cut-out", detailing their awkward postures: "Children in Balthus are uncertain of their bodies. They take stock of them through excess. By continuous contact with their surrounds – the floor on which they slither, the furniture they rub against (measuring themselves by its scale) – they gradually model their awareness of self. At times huge and swollen as a balloon, at others mere filigree, now sturdy as gods, now unable to bear the deformed image thrown back in their face by the mirror, their bodies are a painful and continuous experience of perpetual metamorphosis. The positions they take up – stretched out on the floor, their plane of reference like the meteorologist's sea-level – are incessant attempts to find the posture they need. Coming to the chair, they escalade it, kneel on it, one foot still propped on the floor. They stretch out on the sofa; they reach out over the card table. Later, in Chassy and Rome, the exercise of bathing, washing, using the towel: all these movements explore the limits of their skin and gauge the enclosure of the body". These observations illuminate a whole series of paintings, such as *Getting Up* (p. 40), *The Room*

The Three Sisters, 1964
Oil on canvas, 131 x 175 cm
Private collection

Lorna, Alice and Edith Liddell, photographed by Lewis Carroll, 1858

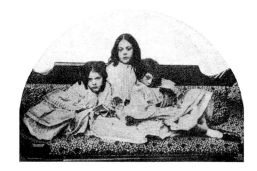

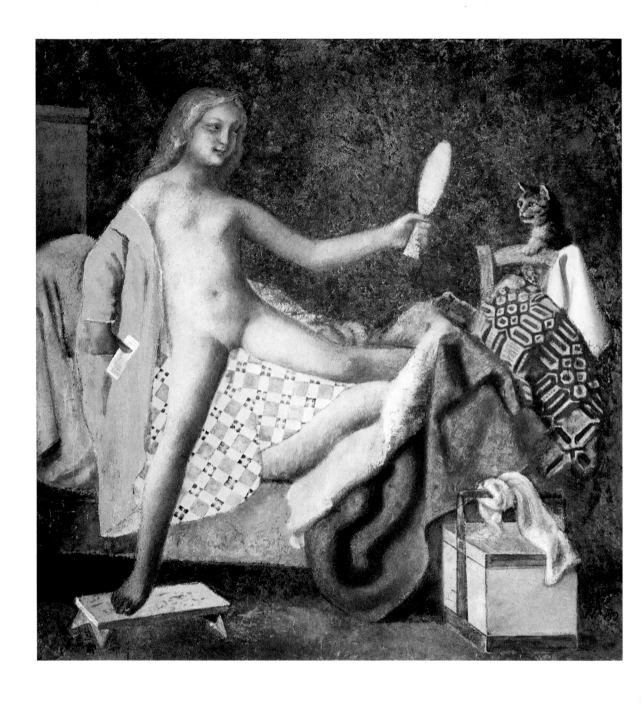

Cat in the Mirror I, 1977–1980
Casein and tempera on canvas, 180 x 170 cm
Private collection

PAGE 45:
Large Composition with Raven, 1983–1986
Oil on canvas, 150 x 200 cm
Private collection

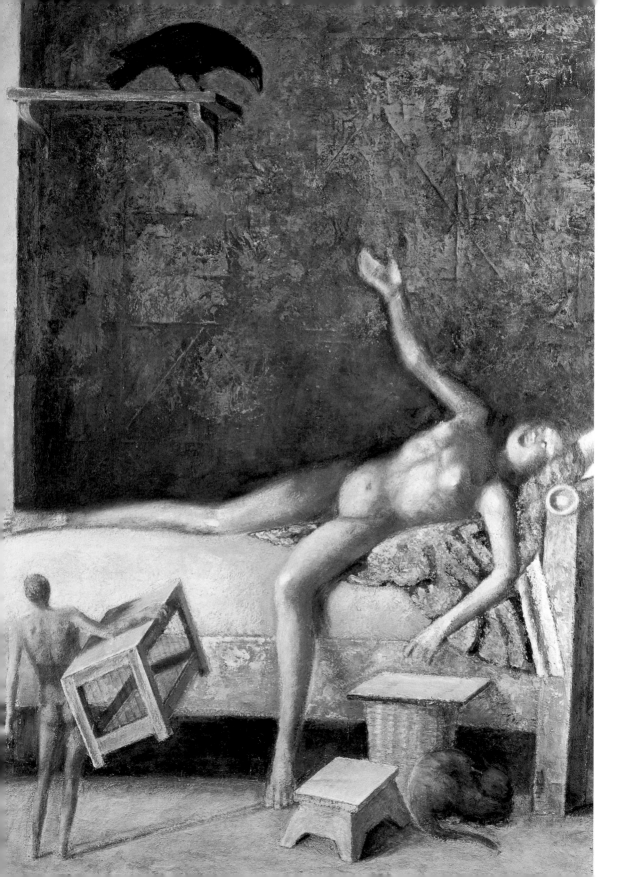

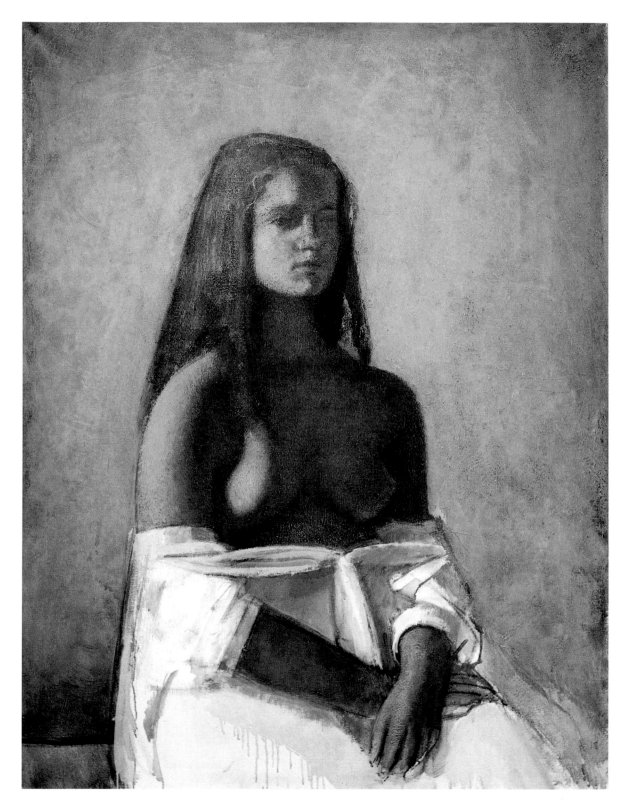

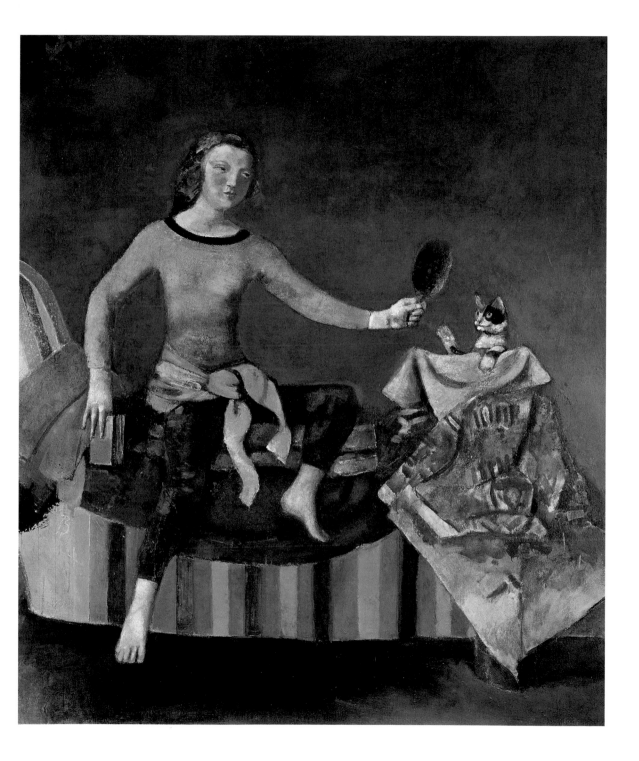

Young Girl with a White Skirt, 1955
Oil on canvas, 116 x 89.9 cm
Private collection

ABOVE:
Cat in the Mirror II, 1986–1989
Oil on canvas, 200 x 170 cm
Private collection

47

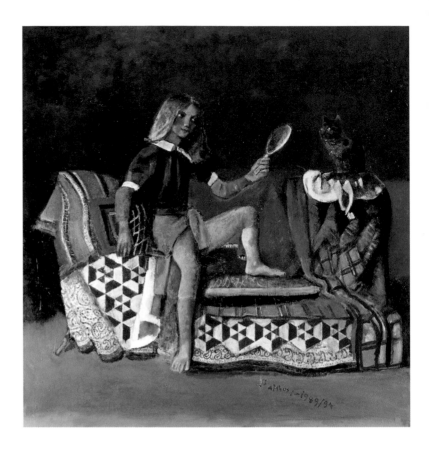

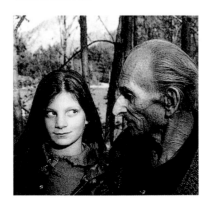

(p. 60), *Young Girl Preparing for a Bath*, *Getting out of the Bath*, *The Blue Cloth*, and *Nude in the Mirror* (pp. 72 to 75).

Who has not seen a sleeping cat mewing and wriggling as it chases a dream-mouse? Balthus loved to combine young girls and dreaming cats. In his *Large Composition with Raven* (p. 45), he seems to have painted both dreamer and dream. Is this Edgar Allan Poe's *Raven*? Has the little naked man seemingly bent on restoring the crow to its cage grown so small because the dream made him so? Or has he shrunk lest he mask the magnificent nude on the bed? Why the analogy with the near-contemporary sleeping *Nude with Guitar* (p. 76)? With Balthus, there is no knowing. The cat, has, this time, turned its back on the scene, either sulking or dreaming its own dreams.

In the Pellerin colour prints devoted to the black cat, which made a big impresssion on the young Balthus, this little nursery rhyme appears:

> The black cat at night
> Sits down to his dinner
> His greed is a fright –
> He gulps down on sight –
> Boy or girl – every young sinner.

If the rhyme can be trusted, the black cat "will only lack for food/ When all the children are good!" But Balthus' children will never be good, nor his cat ever be sated.

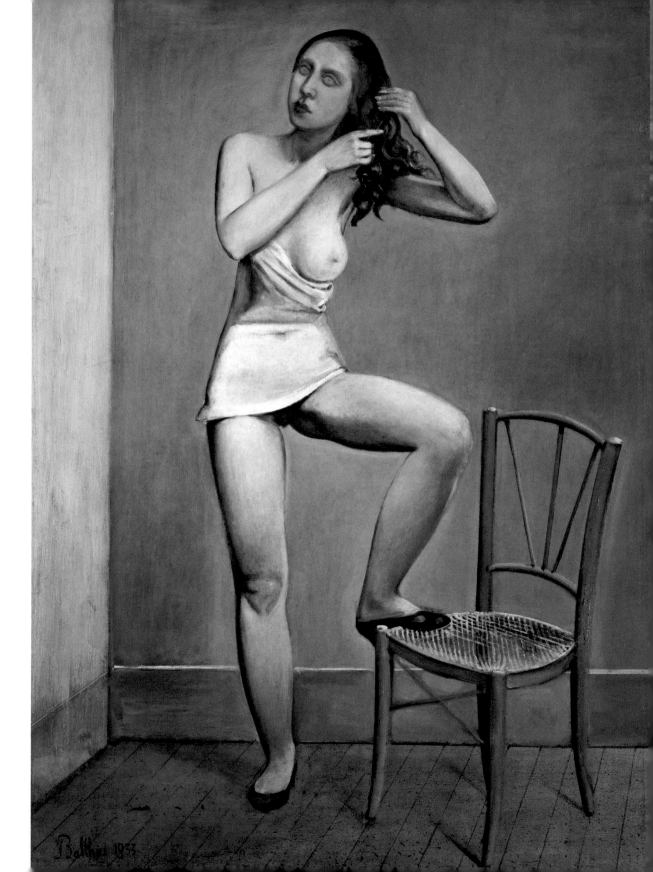

Through the Looking Glass

Balthus's work has proved a magnet for poets, but it took a poet of the calibre of Pierre-Jean Jouve to describe the hallucinations a Balthus painting might provoke in one who lived with it. In an article in *Mercure de France* (1960), Jouve confessed how he had fallen madly in love with *Alice* (p. 50), which hung in his bedroom. *Alice* combines in a single pose a myriad fantasies, as Jouve says: "Imagine a young woman with blank eyes, dressed in a short slip, who, combing her hair with a firm hand, rests one foot on a common or garden chair, thus exposing her mature sex. This strange creature was, of course, my nightly companion, in that she was present when I slept and could therefore enter my head. And no, her excessively heavy left breast and almost emasculate thighs did not give rise to obscure desires, desires born of the past, such as she might perhaps have caused had all of her been at one with the two blue shoes she wore next to the skin. No, what seduced me was this piece of painting, so studied in its precision and so intense in its carnality that I considered *Alice* my mistress. She knew my waking gaze, she knew the secrets of my nights… Had she been other than a painting, she might have said: 'This man sleeps badly'. Thus my intimate relations with Alice. One day, when I woke, I was completely thunderstruck: I could see the thick grey moulding of the frame and yellow tones of the canvas, but the figure had disappeared. I rubbed my eyes; nothing, the canvas was of uniform colour, there was no outline to be seen, Alice had disappeared. The rest of the room was as before. I leapt out of bed. It was true: the Alice I had known for twenty years was no longer in the picture. I spent several days in shock, afraid to mention what had occurred lest I seem deranged. Moreover, my nocturnal relations with Alice would necessarily have been revealed… I began to dream constantly of Alice. She disported herself over me with no little obscenity. Almost all my dreams had taken the form of Alice, as had my daydreaming, for example, in the street… And this was when the real torment began. Alice was everywhere. But Alice, whose character had *become* indecent, who represented a mental aberration on my part, came between me and life and rendered my every next act impossible… When I understood that Alice wanted to make love to me, my essential reaction was *fear*. The sadism of this image pursued both mind and flesh… There came a violent dizziness, a cold sweat… Once more I felt that my heart was moving off toward strange and remote places. Someone must have saved me at that point… no

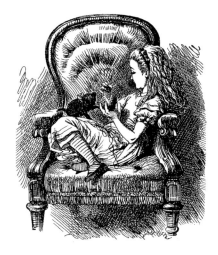

Illustration by Sir John Tenniel for Lewis Carroll's *Alice Through the Looking Glass*, 1872

doubt my beloved wife, who thought I was dying. I recovered my spirits and smiled, others smiled at me, everything was as it should be, and Alice had returned to her place in the frame."

Where does the reality lie, within or without the picture? In the looking glass, vision takes on a conceptual character: things are or are not, exist or evanesce. As the Spanish dramatist Calderón tells us, "All of life is a dream, and our very dreams are dreams". Velázquez's *Rokeby Venus* (1648–1651), hailed by the Inquisition as "a work of the devil", marks the advent of buttocks as the focal point of a masterpiece; Venus turns her back with coquettish disdain, her face revealed only in the sketchy mirror-image. But the picture is no triumph of the flesh. It is an interrogation of the woman's very existence; in the watery instability of the mirror her face is all but dissolved, and ages like some Narcissus contemplating death in his own lineaments. Sumptuously as loin and hip curve toward us, in Venus's languorous pose we see pleasure marked by a grim certainty: this beauty too will ebb.

Girl on a White Horse, 1941
(modified in 1946)
Oil on cardboard, 80 x 90 cm
Current whereabouts unknown

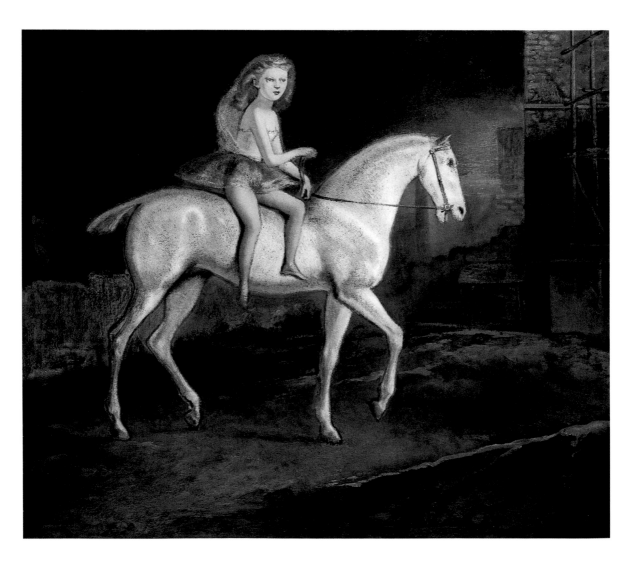

Balthus – dubbed *Bluebeard* by Camus –
in front of the château de Chassy, 1956

In Balthus, the function of the mirror is quite other. Paintings such as *Alice, Happy Days* (pp. 50 and 55), *Nude Before a Mirror* (p. 61), or *Nude in the Mirror* (p. 75), show Balthus's nymphets seeking not time's first outrages, but some reflected clue to their own identity. They are still morphing toward themselves; caught in mutation between chrysalis and butterfly, they consult their own status, scrutinising their transformation with perplexity. This passage from virtual to real maturity is what Balthus seeks: the instant in which his "angels" contemplate their metamorphosis, perplexed by the reflection of their budding womanselves. "In *Alice*," notes Jean Clair, "Balthus represents with astounding accuracy the lack of social and sexual differentiation, the indistinctness preceding the rite, an indistinctness alive with the violence of those who have yet to acknowledge their role. This astonishing figure with her blind eyes prefigures the sleeping girls that Balthus was soon to paint. Absent from herself, ignorant as yet of the alien gaze that dwells on her, she exhibits the more outrageously her attributes, her too heavy breast and prominent, deeply incised sex. Yet nothing could be less erotic than this provocation. For the sight of chrysalis, larva or mummified dead excites no desire. The sole eroticism is that of some *mysterium tremendum*, … the undifferentiated horror of tomb or child-bed."

There is a contradiction here. Are Balthus's *Alices* larvae stimulating only to the entomological antenna, or are they "obscure objects of desire" such as haunt the poet's dreams? The question graphically encompasses the ambiguous connotation of these young girls. We are confronted with the phenomenon implicit in all those portraits, from Titian to Ingres, Renoir to Matisse, that tend toward the nude as to the highest expression of graphic art. The spectator has been granted

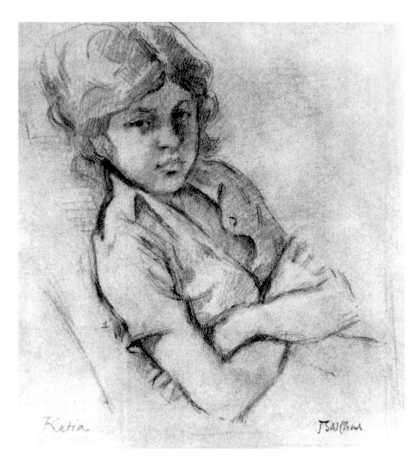

a voyeur's licence, and by the artist's permission contemplates images born of
the painter's unconscious or lucid desire. Each must decide whether, in Balthus's
paintings, his eyes luxuriate in "angels" or "Lolitas". Do these bodies acknowledge
the desire they excite? Or are they merely clothed in the attractions they unwit-
tingly exhibit? When accused of erotic or perverse intentions, when it was said
that the little girls who had made his name were not innocents but meretricious
Lolitas, Balthus, angered, was categoric: "I have only ever painted angels. Besides,
everything I paint is religious". And religious it no doubt is, just as Michelange-
lo's *Ignudi* are religious. Let us not be excessively hypocritical. Even very young
girls are aware of what takes place around them, and great painters are very con-
scious of the meanings that inhere in the paint that they place on canvas. Bal-
thus's angels have the slightly acid, perverse savour of *Alice in Wonderland*, and
we know that the Reverend Dodgson, better known as Lewis Carroll, also loved
little girls, inventing fairy tales for them and photographing them as he did Alice
Liddell, the inspiration for Alice (p. 41).

To his grandfather – a close friend of Daguerre and great *aficionado* of pho-
tography – Francis Picabia declared: "You can photograph a landscape, but you
can't photograph what I have in my head". His retort summarises the divide

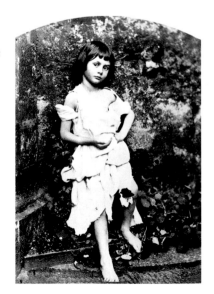

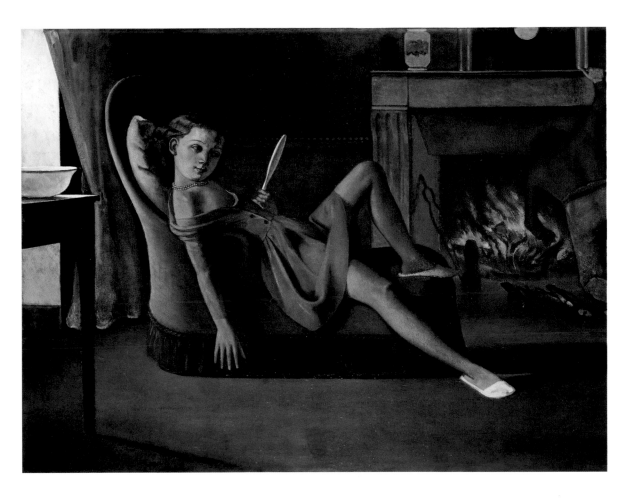

between photography and painting. These two arts can be neither confused nor compared, but an allocation of functions has slowly been accomplished. The myth of the real is now the business of the photographer, and it is for the fine arts to abstract therefrom: literally to "realize" what has never before been seen, to draw visions forth from the void. For modern art is no longer exclusively visual. Delacroix had the photographer Durieu make pictures of nudes posed to his own specification, and used them alongside live models in his studio. Following in his footsteps, Balthus, while Director of the Villa Medici in Rome (1961–1977), took photographs of two young sisters, Katia and Michelina. They were the daughters of a Villa Medici employee, and Balthus made them his models, first Katia, from 1967, and then Katia's younger sister Michelina, from 1970. But the two sisters didn't always feel like posing, and though our painter (like Lewis Carroll) took a hint from Scheherazade and broke off his stories at midpoint, they often preferred to play. The photo of *Katia Reading*, for example, allowed the painter to finish the painting eight years after Katia had first posed for him, when she was already a young woman. Motifs from these photos fed into later paintings such as *Katia Asleep*, *Katia Reading* (p. 59), and Katia with her arms crossed (p. 54). Michelina features in similar photos and paintings (p. 62),

Happy Days, 1945–1946
Oil on canvas, 148 x 200 cm
Washington, Hirshhorn Museum and Sculpture Garden, Smithsonian Institution. Gift of the Joseph H. Hirshhorn Foundation

Katia Asleep, 1969–1970
Pencil and charcoal on paper, 70 x 70 cm
Current whereabouts unknown

PAGE 56:
Thérèse, 1938
Oil on canvas, 100.3 x 81.3 cm
New York, The Metropolitan Museum of Art.
Bequest of Mr. and Mrs. Allan D. Emil,
in honour of William S. Lieberman

notably the very large painting now in the Centre Georges Pompidou, *The Painter and his Model* (p. 78). For this, Balthus snapped Michelina propped on a chair, reading a Tintin album – whose graphic style Balthus, incidentally, rather admired.

As we have seen, Bonnard was, along with Derain and Maurice Denis, one of the artists who taught Balthus the art of painting. The young artist must have been familiar with the "box" camera used by Bonnard to such fine effect in series like *Marthe in the Tub*. Bonnard's photographic portraits were inseparable from his paintings on the same themes; they helped him to master the art of framing and foreground incident. Like Delacroix seeking the aid of Durieu, Balthus had recourse to a photographer for the image, but himself determined the pose, costume and lighting of his models. Degas's admirable photographic portraits

LEFT:
Georgette Dressing, 1948–1949
Oil on canvas, 92 x 96.5 cm
New York, The Elkon Gallery

BELOW:
Study for *Katia Reading*, 1968–1970
Pencil, 45 x 40 cm
Private collection

show his models emerging from a coal-black penumbra like apparitions, their features strongly modelled by the light. Balthus too chose strong contrasts, in which his model gleams pale amid the surrounding shadow. The slender sensuality and freedom of posture – the energy of the young animal – that Bonnard had discovered in Marthe, Balthus too captured. The adult Michelina later said: "I sometimes meet people who do not like Balthus, who find him bizarre, who find his sensuality or his eroticism peculiar, and on each occasion I tell myself that they do not see the painting as I do. For me, he is someone who successfully represents the moment when an important transition occurs, that from child into adulthood." Faced with these barely nubile bodies, forever stilled at the moment of "transition", one inevitably returns to Lewis Carroll and the young Alice Liddell seen "through the looking glass" of the lens. Carroll's photographs are of very young girls, in whom puberty has not yet begun, their breasts the faintest swellings on their elastic chests. More even than drawings, Carroll's photographs illuminate the vulnerability of the child.

So Balthus's paintings are religious? No doubt they are, but on condition his subject is not. "A primitive might have painted an angel thus", said Artaud of *Lady Abdy* (p. 15). *Dream I* (p. 66) confirms the religiosity of the painter. It shows his niece by marriage, Frédérique, who, with the move to the château de Chassy, became Balthus's favourite model. Depicted at seventeen in a red skirt and green blouse, she resembles nothing so much as an angel painted by Piero della Francesca. And the girl who enters the painting, red flower in hand, might be the

angel of the Annunciation. *The Golden Fruit* (p. 67) is a more three-dimensional variation of *Dream I*, and it too possesses the stilly quality, as if outside time, of a Piero. Is this a fairy story or an adolescent dream? Whatever the case, its setting is a real one, the living room of the château de Chassy, faithfully represented, its still-life – coffee pot, cup, tray, and napkin – offering a deliberate contrast to the dreamlike movements of the protagonists. Dreamer and dream were painted by Balthus using the technique and materials of the Renaissance, and from these he derives the softness and subtle veiling effect that imbues pictures like *Dream I* and *The Golden Fruit*, imparting a sense of the unreal. "I wanted," Balthus says, "to obtain a surface like that of fresco, a matt surface with little (very little) sheen. I tried various paints and what suited my purposes best was *casearti*, a mixture of casein and *gesso*, plaster, which you mix with oil colours." And so Balthus's paintings, always of fairly large format, gradually become a variant of fresco. Growing closer than ever to his idol Piero della Francesca, he painted *The Moth* (p. 79), in which the eponymous insect is about to burn its wings at the incandescent flame

Katia Reading, 1968–1976
Casein and tempera on canvas, 179 x 211 cm
Private collection

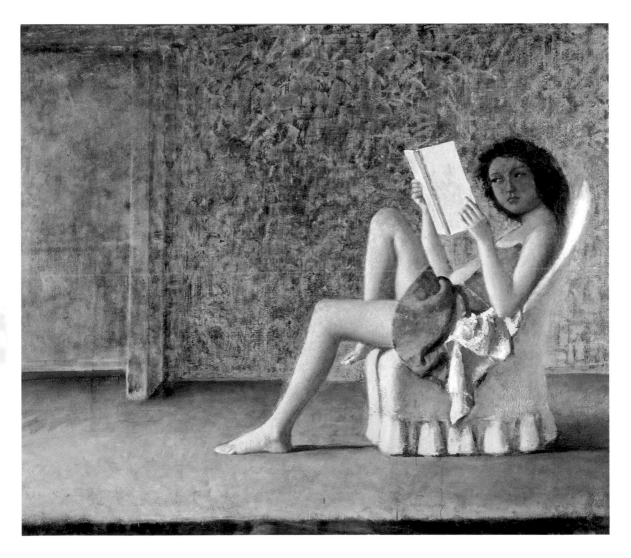

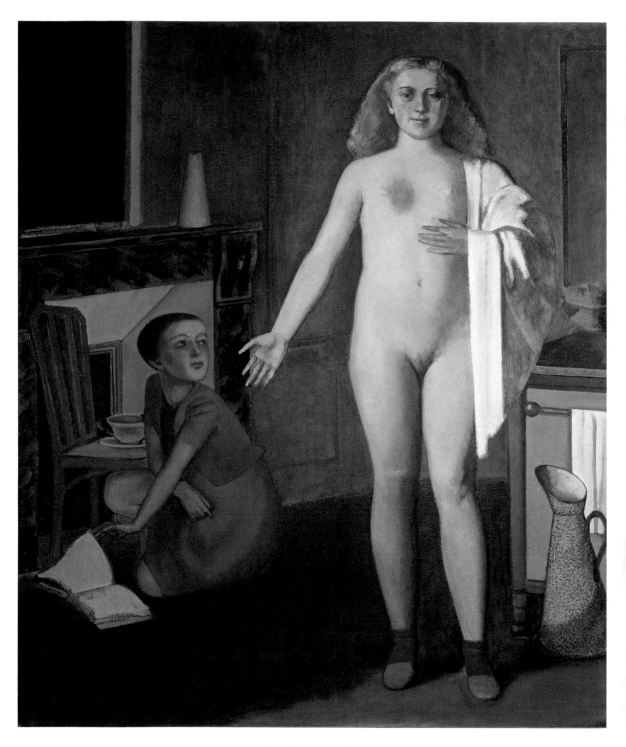

The Room, 1947–1948
Oil on canvas, 189.9 x 160 cm
Washington, Hirshhorn Museum and Sculpture Garden, Smithsonian Institution.
Gift of the Joseph H. Hirshhorn Foundation

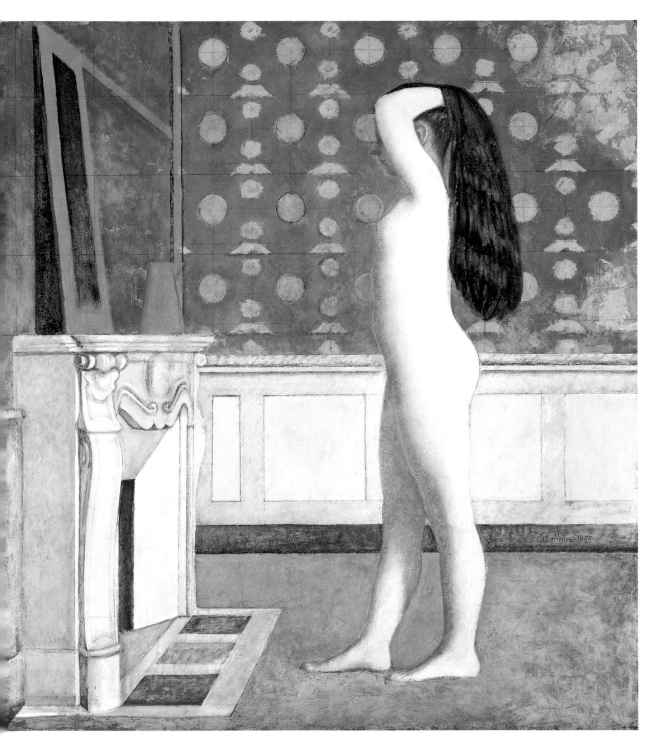

Nude Before a Mirror, 1955
Oil on canvas, 190.5 x 164 cm
New York, The Metropolitan Museum of Art.
Robert Lehman Collection

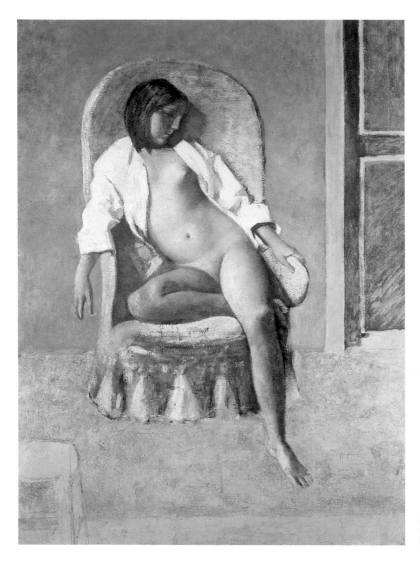

Nude in Repose, 1977
Oil on canvas, 200 x 150 cm
Private collection

of an oil lamp. Is it a symbol? Does it prefigure some tragedy about to overwhelm the naked heroine? The rougher surface of this painting was a foretaste of the direction Balthus's art would take after his move to Rome. There he painted successive variations on *Three Sisters* (p. 43) or *Cat in the Mirror* (pp. 44, 47, and 48), in his quest for distinctions of colour, palette and surface. "These variations, to which I so often have recourse," he said, "are the fruit of dissatisfaction. If I had been satisfied there would have never have been several versions of *Three Sisters*, nor three versions of *Cat in the Mirror*. I am amused by the art historian who perceives in these variations on the 'sisters' theme some sort of sexual intention. What impelled me was rather 'my personal mathematics', the admiration that I feel for Piero with his 'concerts of angles'. These pictures were prepared by division of space, by diagonals that established the ground and govern it invisibly".

What Claude Roy called "the Balthus colour-wash" was applied by Balthus in the restoration and even decoration of the Villa Medici, the site of the French

PAGE 63:
Young Girl with Mirror, 1948
Oil on cardboard, 100 x 80 cm
Private collection

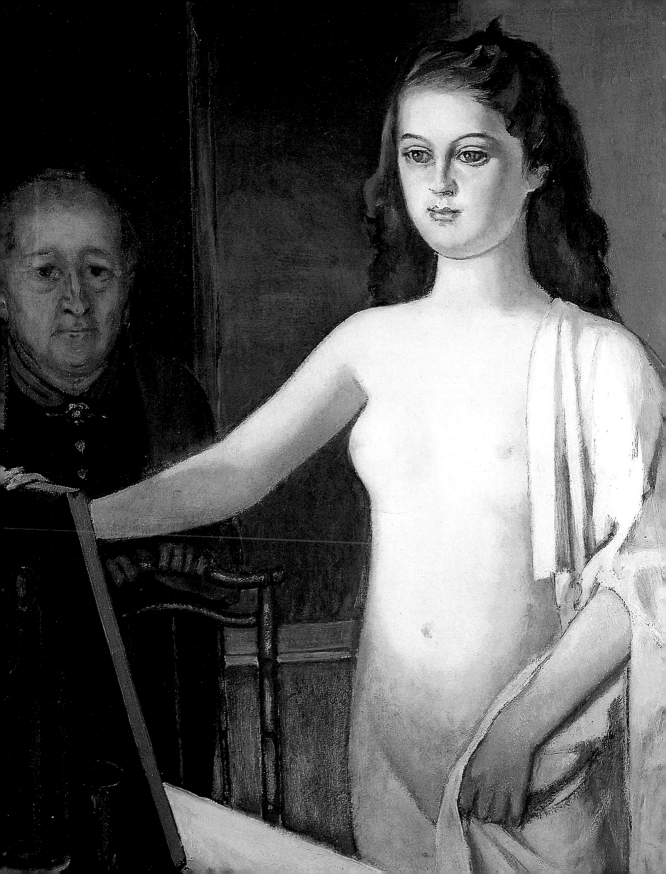

Academy in Rome (appointed Director of the Academy by André Malraux, Balthus lived there from 1961 to 1977). It was a "mixture of two or three colours applied with a sponge or flecked with a brush. The colour obtained gives the impression of a sort of muffled vibration, a 'living' surface." Horace Vernet, Director of the Villa Medici in 1830, had had a "Turkish" room created on the top floor of the building. There Balthus painted *The Turkish Room* (pp. 80/81), *Japanese Woman with Black Mirror* (pp. 82/83) and *Japanese Woman with Red Table* (pp. 84/85). In these paintings, he sought to reconcile Western perspective with an Oriental vision. Not content with appointing Balthus to the Rome Directorship, Malraux also sent Balthus to Japan to organise exhibitions of French art. There he met Setsuko, first his interpreter, then his model and inspiration, and finally his wife. Setsuko posed for all three paintings. In the last stage of his life, when he moved from the Villa Medici to the Grand Chalet in Switzerland, her influence imparted to Balthus what an Edo poet had observed of the so-called "painter of calm things": the capacity to "paint portraits of the artist through the medium of objects". Thus, in the Moorish chamber of *The Turkish Room*, it was Setsuko who modelled as odalisque. Every detail of this painting subtly reflects the presence of the artist. The décor supplied by Vernet's "Turkish" room faithfully reflects the Orientalim fashionable when Ingres painted *Turkish Baths* in 1863, in his eightieth year, precisely one hundred years before Balthus's painting. In 1836, Ingres had succeed Vernet at the head of the Villa Medici. The nude

Reclining Nude, 1945
Oil on canvas, 44.5 x 59.7 cm
Private collection

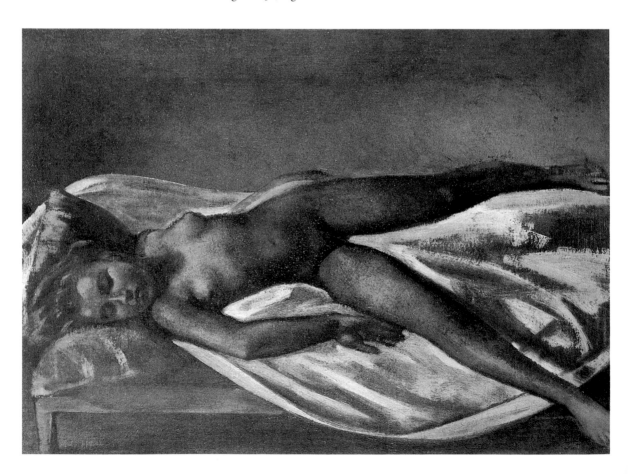

The Victim, 1939–1946
Oil on canvas, 133 x 220 cm
Private collection

itself was a homage to Ingres, while the picture comprises a number of symbols of femininity, such as the Japanese mirror of polished metal, an Oriental symbol of the female soul, and the eggs in a bowl in front of the window. The still-life on the right, with cup and vase on a round table, are perhaps a tribute to Giorgio Morandi, the Italian master of still-life. Morandi died in 1964, while Balthus was painting this work; his technique as painter was akin to Balthus's. Setsuko also posed for *Japanese Woman with Black Mirror* and *Japanese Woman with Red Table*, two paintings derived from the Japanese *Shunga* genre, in which the erotic image symbolises vernal renewal. But that tradition requires rather skimpy figures, whereas Balthus made large close-ups, like those of Utamaro in the late 1870s. They depict a young woman who, after making love, returns the reversed mirror to study how love has made her still more beautiful and desirable.

Balthus had felt at home with Oriental art since his childhood. At thirteen, he read a book on China and its painting, which was to mark him for ever. He began to delight in everything that came from the Far East, in particular in his discovery of the life and work of the Tao master, Tchuang-Tren. Rilke had been very struck at the sight of what he called, in a letter to the young Balthus, "the drawings with which you have spontaneously illustrated your memories of the Chinese novel". He deemed the young man to have shown "art instincts" of great profundity in these drawings, and thought "their invention… charming" and "produced with an ease that shows the wealth of your inner vision". This was the point at which Rilke announced that painting was his young friend's vocation. Balthus, who spent much of his childhood in Savoy, in the mountainous Busey region of Switzerland, recognised in that landscape echoes of the reproductions he had seen of Song dynasty landscapes. Thereafter, he looked out on the Swiss mountainscape with the eyes of a Chinese landscape painter. The many land-

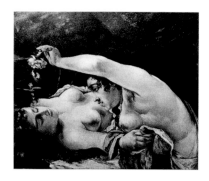

Gustave Courbet: *The Awakening* or
Venus and Psyche (detail), 1866
Berne, Kunstmuseum

scapes that he painted throughout his career, from *The Mountain* (pp. 18/19), and *Champrovent Landscape* (p. 22), to the tree-scattered *Triangular Field* (p. 24) were all influenced by the Japanese landscape prints and exhibit the overhead perspectives and use of shadow characteristic of Hokusai and Hiroshige. "In my childhood and adolescence," he told Philippe Dagen, "spent in the mountains, I looked out on mountains, snow and winter. When I encountered Chinese and Japanese painting, I found the same vision of nature. This triggered my passion for Far Eastern art. Nothing I did was *japonisme*. No. But there was kinship of vision that encouraged me as soon as I perceived it; it wasn't an influence. Barthes has defined Japanese art perfectly. He entitled his book *The Empire of Signs*, and he's exactly right: signs." And though "East is East, and West is West, and ne'er the twain shall meet", in Kipling's words, Balthus, in a passage worthy of André Malraux's *Musée imaginaire*, defines the similarities: "It is not just the Chinese and the Japanese who have painted this way. There were also the Siennese, who did so for philosophical reasons. In the West, the break came later, at the Renaissance, when perspective introduced what is generally considered a more 'realistic' notion of representation. I do not share this conception. Nor, for that matter, did Courbet. People call him realist, but that's

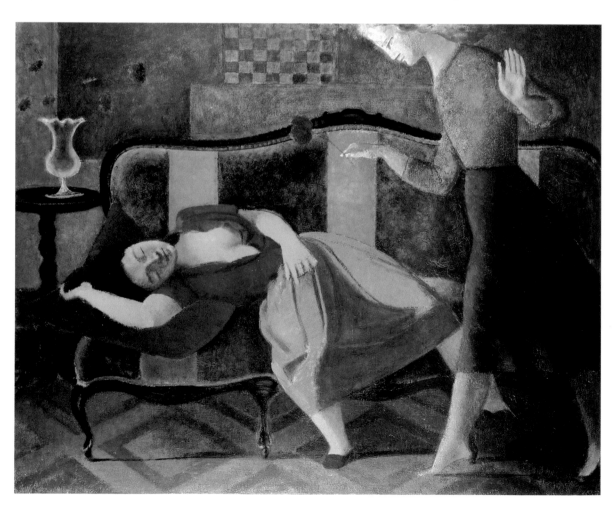

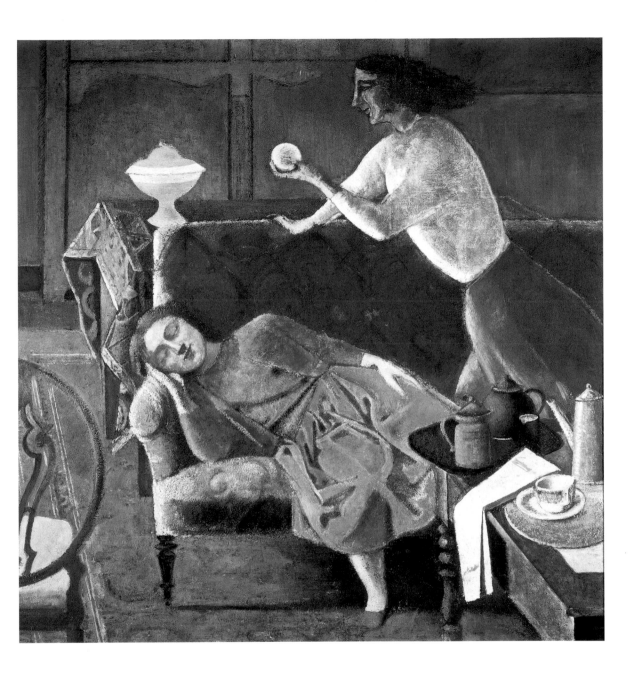

The Golden Fruit, 1956
Oil on canvas, 159 x 160.5 cm
Private collection

PAGE 66:
The Dream I, 1955
Oil on canvas, 130 x 163 cm
Current whereabouts unknown

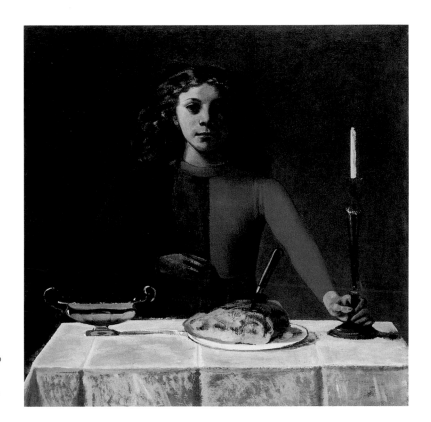

Girl in Green and Red (The Candlestick), 1939
(modified in 1945)
Oil on canvas, 92 x 90.5 cm
Ancient collection of The Museum of Modern
Art, New York

PAGE 68:
Portrait of Frédérique, 1954
Pencil on squared paper, 22 x 16.5 cm
Private collection

absurd. Among Western painters, Courbet is, with the Siennese and Breughel, one of the very few who have some kinship with the Chinese. They all have the same conceptions, the Chinese conception of painting, which tends not toward representation of the thing, but to identification with it… The great Western painters are those who have not experienced that break with the Oriental." The basic principle of Oriental painting is, after all, contained in the famous adage: "One should not represent the mountain, one should oneself become the mountain". In this, Balthus heard an echo of Dante's prescription – *The Divine Comedy* was his bedside book – "He who paints a figure, if he cannot become that figure, cannot paint". In a similar spirit are the verses of Tu Fu, which Claude Roy had shown him. Balthus, who often waited several years before he considered a painting complete, took them to heart: "Five days painting the one waterfall / Ten days painting a single rock / Ceding to neither impatience nor haste / Only then does Wang Tsai take up the brush / And set down on paper his masterful touch".

This kind of mastery, the artist's willingness to acknowledge that he was painting directly for the museums, combined with his vaunted refusal to work any faster than he desired, tended to raise the hackles of the art establishment. It was a time when prominence was an invitation to be "cut down to size", a time of Procrustean egalitarianism. Thus Philippe Dagen, considering *Champrovent Landscape* (p. 22), exhibited in Venice, is exasperated by the work, not least by its date, 1941–1945. "In a manner so visible that one can but attach meaning to his emphasis, the author loudly declares that he took four years to bring the work to what he considers a state of completion. Now, one has scarcely laid eyes on it before the comparisons and reminiscences well up: Poussin, Corot, Courbet.

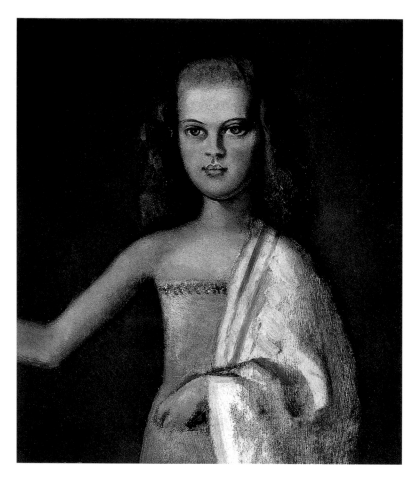

The composition in intersecting curves is a model of its kind. The perspective methodically layers the successive planes as far as the blue-tinged mountains indistinct on the horizon. The effects of sunlight on the leaves are now indicated by touches of very pale yellow slightly raised by impasto. The late afternoon light is admirably distributed over the meadows, hillocks, hedges and mature trees. This painting aspires to be a masterpiece. And that's precisely what's awkward about it: this mastery, this labour, this artistry, which, were they not so ostentatious, would be quite remarkable. The picture has been painted like a demonstration. But what use is such a demonstration?" And Dagen answers his own question: "*Champrovent Landscape* is a history of painting that at length proves intrusive and even exasperating. Or, to put it another way, the invasion of the work by the religion of painting, is, in the absence of any other passion, provocative." Has the angel of the bizarre, who so often whispered in his ear, now abandoned him? Classicism eliminates perversion. Not all at once… There is a gradual process… *The Game of Cards* (p. 21) and *Passage du Commerce-Saint-André* (p. 12) retain disturbing anomalies, though the texture of the painting has thickened and the geometry of these compositions has become tyrannical. But the fatal step had been taken: now, the required thing was handsome, expert, finished paintings, and handsome, smooth, classical drawings. In Chassy, Rome

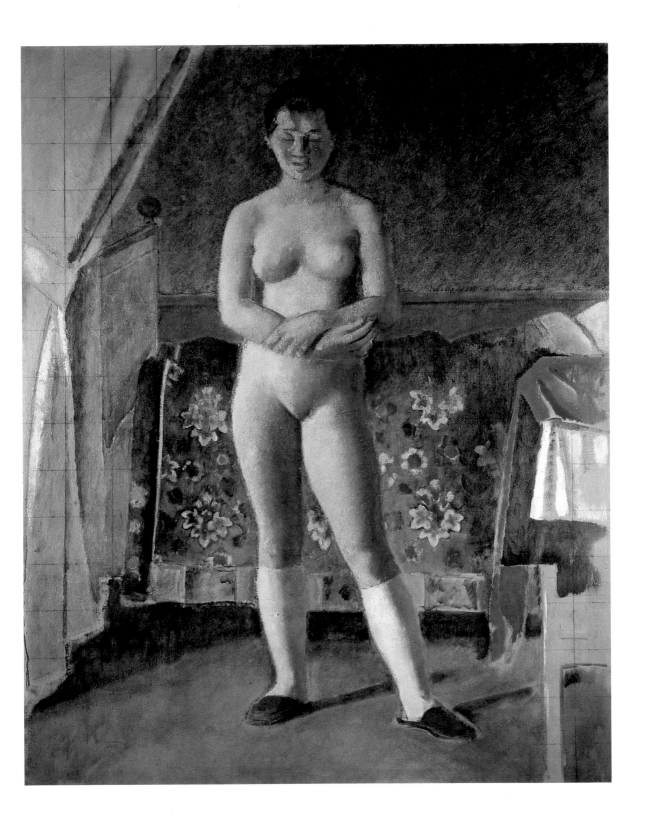

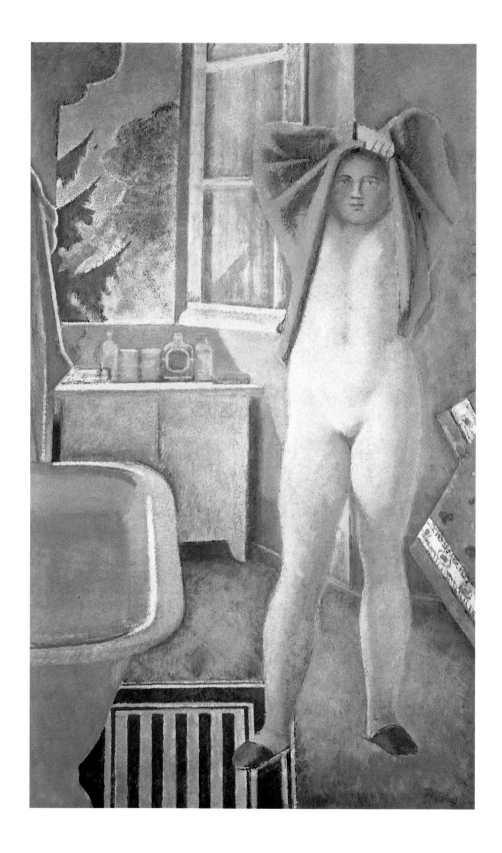

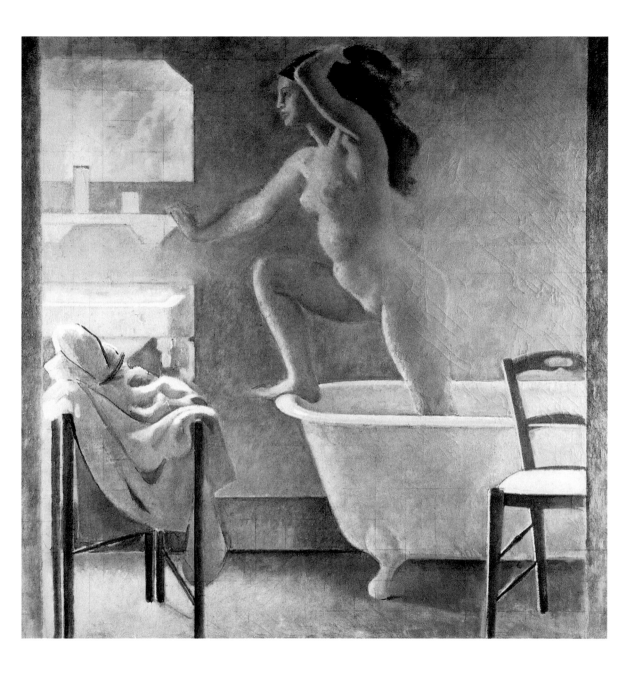

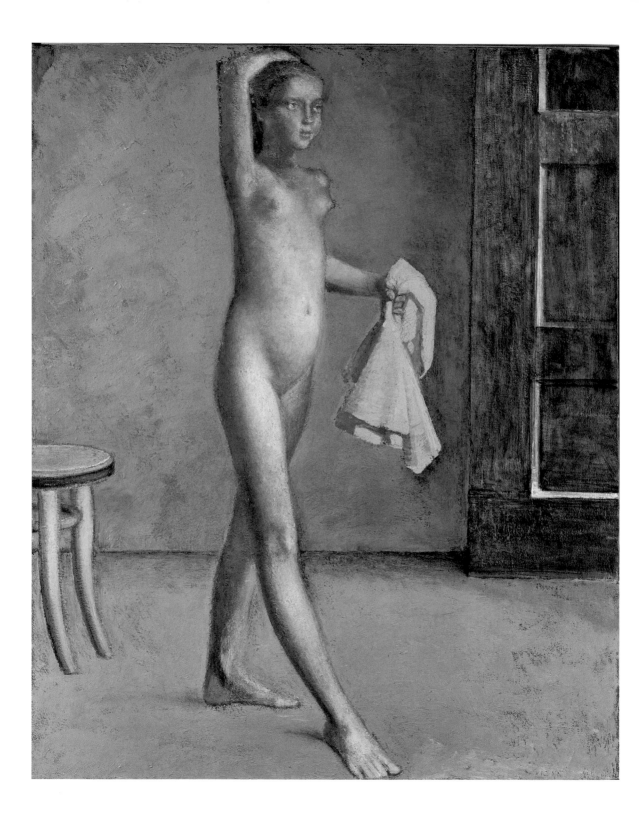

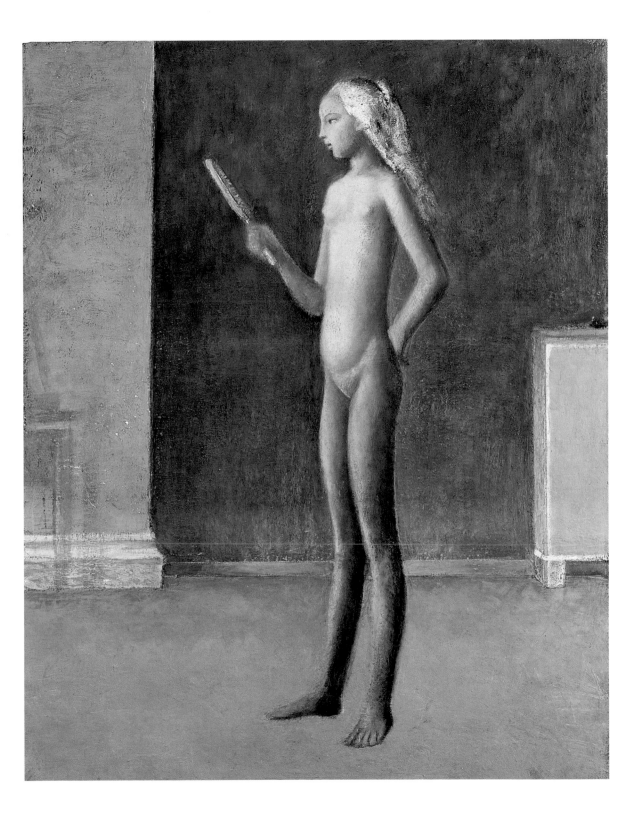

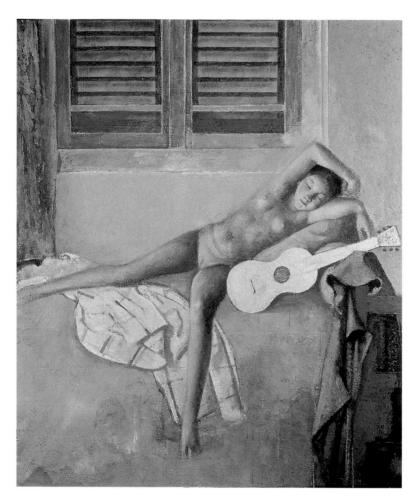

Nude with Guitar, 1983–1986
Oil on canvas, 162 x 130 cm
Paris, Musée National d'Art Moderne –
Centre Georges Pompidou

and Rossinière, Balthus… met this prescription with unflagging zeal. He conceived and executed large, complex compositions in which we sometimes perceive reminiscences of his earlier works. But these are ghostly memories, lacking the dry, cold, cruel aggressiveness of before. The colour harmonies are agreeable, the touch velvety or slick, and the paintings are on a very large scale, worthy of major collections or great museums, to which they have for the most part found their way. The drawings made in the French Academy at Rome take classical ambition to an extreme; Balthus, following in Ingres's footsteps as a Director of the Villa Medici, wishes to rival Ingres, his predecessor. He seeks at any cost to become timeless and non-contemporary. And he has succeeded. Nothing remains of Artaud's definition but 'the technique of David'; the 'violent, modern inspiration' has vanished." Balthus might have replied to this post-mortem diatribe as he did to Richard Gere in 2001. His words cannot help but remind us of Paul Valéry's 1920 warning against Modernism. "I detest the modern," Balthus said. "What does it mean, to be modern in painting? Today's painters don't know how to make a painterly phrase. Before, a least a minimum technique was required. I remember, when Miró showed him his last paintings, Picasso asked,

PAGE 77:
Sleeping Nude, 1980
Casein and tempera on canvas, 200 x 150 cm
Private collection

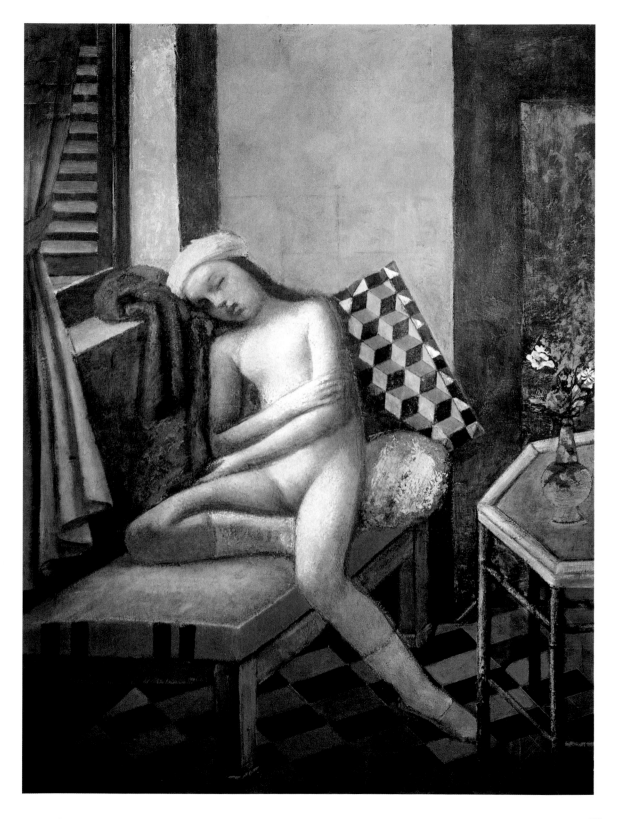

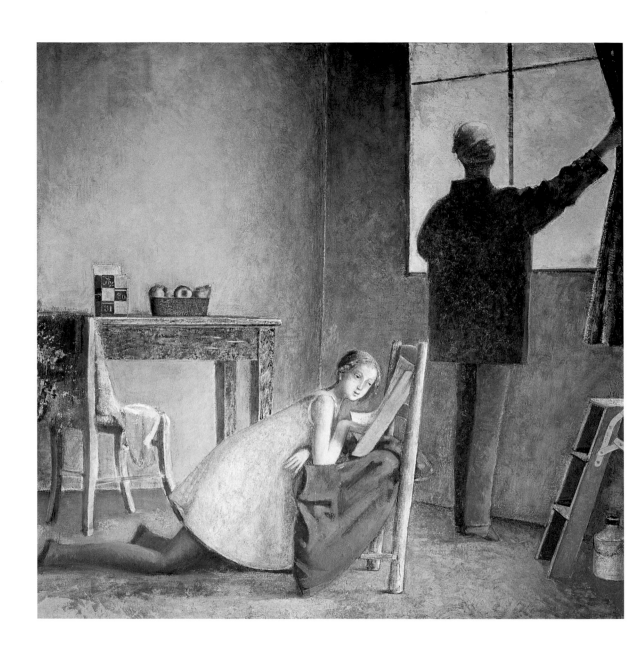

The Painter and His Model, 1980–1981
Casein and tempera on canvas, 226.5 x 230.5 cm
Paris, Musée National d'Art Moderne –
Centre Georges Pompidou

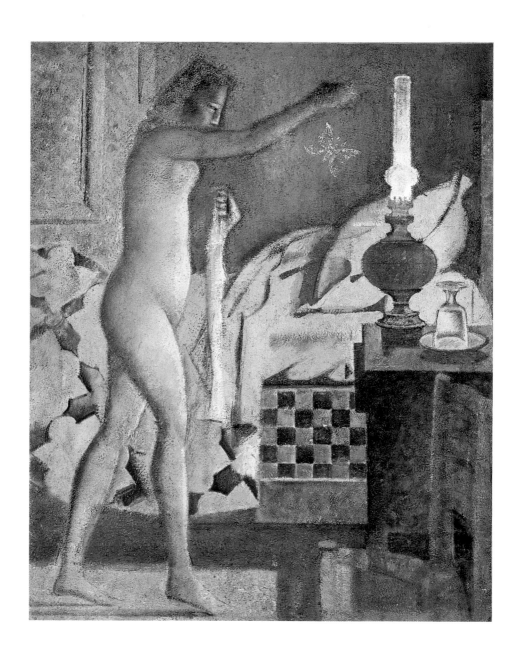

The Moth, 1959
Casein and tempera on canvas, 162 x 130 cm
Paris, Musée National d'Art Moderne –
Centre Georges Pompidou

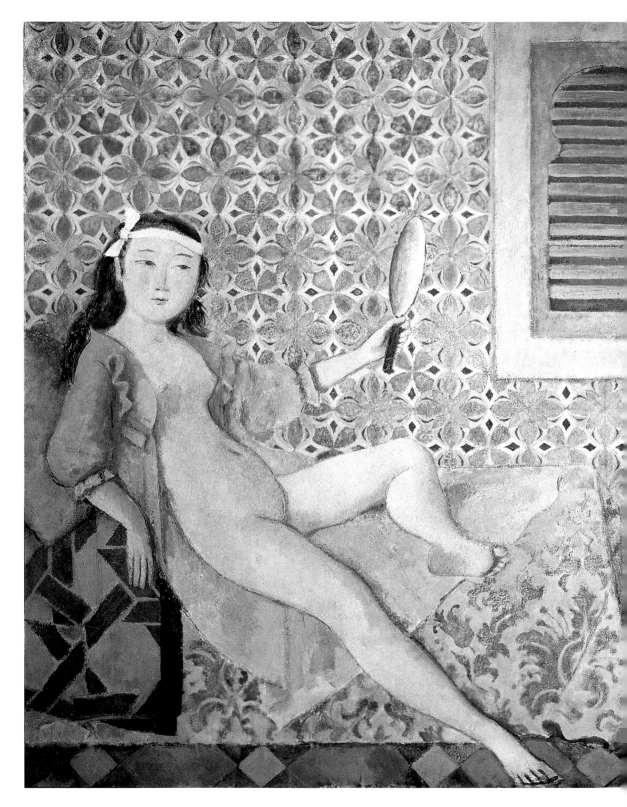

The Turkish Room, 1963–1966
Oil on canvas, 180 x 210 cm
Paris, Musée National d'Art Moderne –
Centre Georges Pompidou

B. 1963

Half-Length Portrait of a Girl (Setsuko), 1963
Pencil, 57 x 43 cm
Private collection

Japanese Woman with Black Mirror, 1967–1976
Casein and tempera on canvas, 157 x 195.5 cm
Private collection

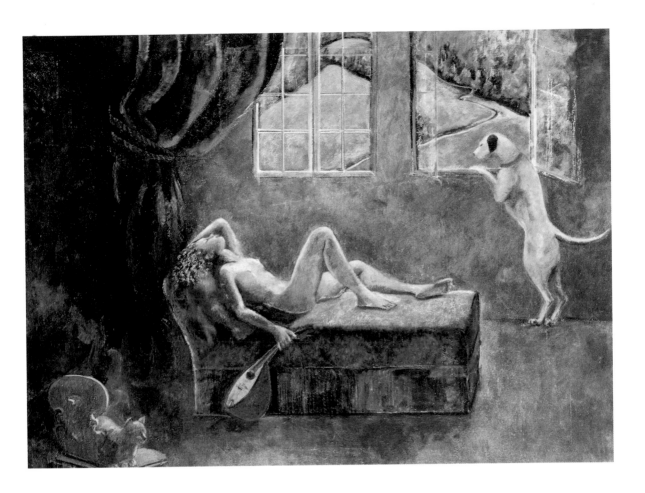

'Miró, how can you do things like this at your age?' I feel as though my world no longer existed. I understand nothing about our epoch. It's as if ugliness had come to dominate the planet."

Out walking one day, after they had left the Villa Medici, Balthus and his wife stumbled serendipitously upon the Grand Chalet. Its date of construction was inscribed on the façade: 1754 (p. 88). "Two years before Mozart's birth," was Balthus's enthusiastic response, "You might have mistaken it for an old Japanese house. We fell in love with it on sight, and when we heard the owners say 'We want to sell, but no one is interested', we bought it on the spot!" We have seen that Picasso deemed himself and Balthus "two sides of the same coin". Did he mean that they were the last two painters who could be invoked in proof of the continued vigour of painting? Claude Lévi-Strauss said of Picasso: "his genius consisted above all of persuading us that painting still exists. I have an image in my head: on the desolate coastline where the shipwreck of painting has stranded us, there is Picasso, gathering the flotsam and improvising with it…" But one might also say that Balthus, by painting direct for the museums, by bringing back to life – in his own way – Courbet, Piero and Oriental painting, has also given us an illusion of painting's continued existence. Roger Caillois, in *Picasso the Liquidator*, perceived in the Spaniard the "conscious, sardonic liquidator of an enterprise several hundred years old, whose disintegration he

Expectation, 1995-2001
Oil on canvas, 245.5 x 190.5 cm
Private collection (Balthus's estate)

PAGE 86:
Still-life, 1983
Oil on wood, 100 x 80.7 cm
Private collection

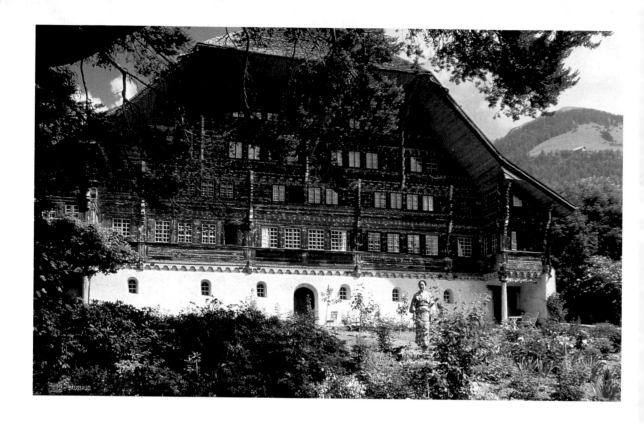

Setsuko, Countess of Rola, in front of the Chalet
Suisse, Rossinière, a former hotel built in 1754

could not help but foresee". Was Balthus, by contrast, the "conservator", a man
of infinite patience attempting to shore the fragments of painting's ruin? On
the base of his pencil drawing of Michelina (1976), which he dedicated to his
son Stanislas, Balthus copies out the last verse of Lewis Carroll's poem from
Alice in the Looking Glass:

> And, though the shadow of a sigh
> May tremble through the story
> For "happy summer days" gone by
> And vanish'd summer glory –
> It shall not touch with breath of bale
> The pleasance of our fairy-tale.

PAGE 89:
Balthus, photographed by Martin Summers
at the Grand Chalet, 1994

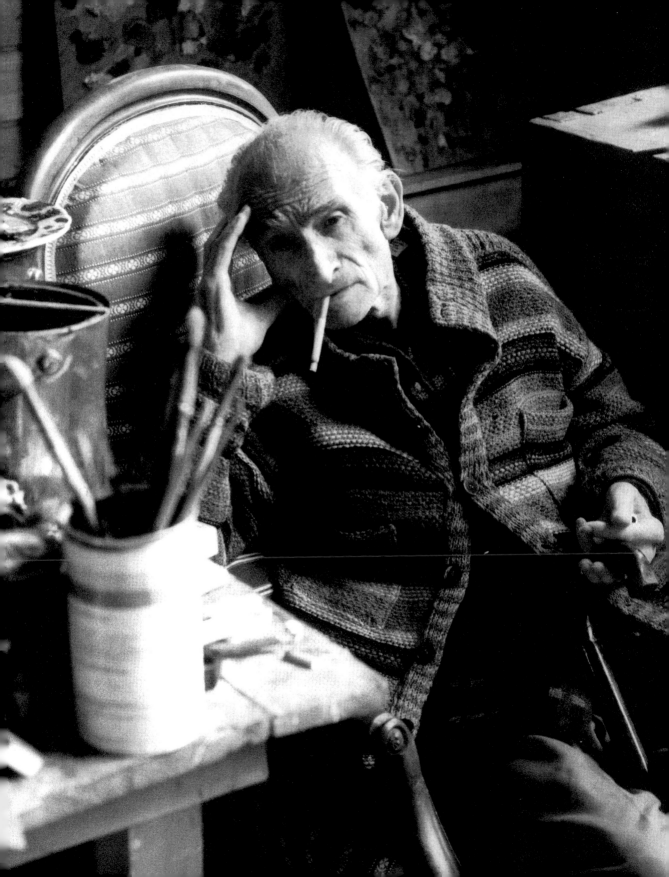

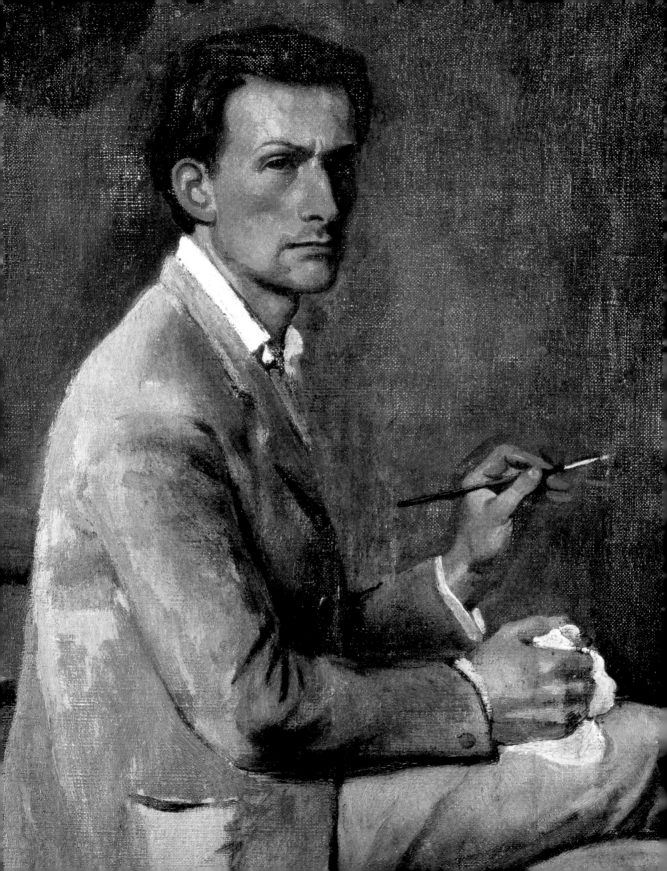

Balthus

Life and Works
1908–2001

"Balthus is a painter of whom nothing is known. Now let us look at the pictures".

1908 On 29 February, Count Balthasar Michel Klossowksi de Rola, known as Balthus, is born, the second son of Erich Klossowski (1875–1946), a painter and theatre designer, and Elizabeth Dorothea Spiro (1886–1969), known as Baladine, also a painter, who subsequently became Rilke's muse. Balthus's elder brother is the writer and painter Pierre Klossowski, b. 1905.

1914 The Klossowski family, of German nationality, leaves Paris for Berlin.

1917 Baladine and her two sons set up house first in Berne, then in Geneva.

Self-portrait (detail), 1943
Pencil, 63 x 45.7 cm
Private collection

PAGE 90:
Self-portrait (detail), 1940
Oil on canvas, 44 x 32 cm
Private collection

1919 Baladine meets Rainer Maria Rilke. Balthus enrolls at the lycée Calvin. He spends his summer at Beatenberg, near Thoune Lake; there he works as assistant to the painter and sculptor Margrit Bay.

1920 Balthus illustrates a Chinese novel for Rilke.

1921 Publication of *Mitsou, Forty Images by Baltusz*, with a preface by Rilke. Baladine and her sons return to Berlin.

1924 Baladine and her two sons return to Paris. Balthus takes courses at the académie de la Grande Chaumière. Shows his drawings to Pierre Bonnard and Maurice Denis, who encourage him to copy Poussin's paintings in the Louvre.

1926 Balthus spends part of the summer in Italy. He copies frescoes from Piero della Francesca's cycle, the *Legend of the True Cross*, at Arezzo, and Masaccio frescoes in Florence.

1928 Seven-month stay in Zurich, where he paints several portraits.

1929 Trip to Berlin and Zurich, where the first exhibition of his works takes place at the Forter gallery.

1930 Fifteen months' military service in Morocco, where he makes a few drawings.

1932 Spends the summer in Berne, where he paints a series of copies of Joseph Reinhardt's *Cycle of Swiss Peasant Costumes*. On his return to Paris in the autumn, he shares an apartment with friends Pierre and Betty Leiris. Begins illustrations for Emily Brontë's *Wuthering Heights*. Meets Pierre-Jean Jouve and André Derain; the latter offers him technical advice.

1933 Moves into his first studio, at 4 rue de Furstemberg. Receives a visit from a delegation of Surrealists: André Breton, Paul Éluard, Alberto Giacometti and Georges Hugnet, come

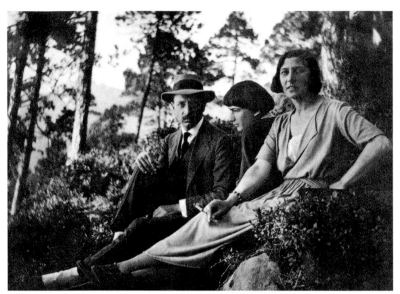

1936 Moves into a new studio in the Cour de Rohan. Exhibits his illustrations for *Wuthering Heights* in London, but no one wants to publish them. Paints the *Portrait of André Derain* (p. 16). Begins a series of paintings for which the Blanchard children model.

1937 Marries his first wife, whom he has known since childhood: Antoinette de Watteville: the model for *The Mountain* (pp. 18/19) and *White Skirt* (p. 13).

to see him at work on paintings that they have heard about. The art historian Wilhelm Uhde introduces him to Pierre Loeb, owner of the Galerie Pierre.

1934 His first solo exhibition at the Galerie Pierre in Paris. There he shows *The Street* (pp. 10/11), *Cathy Dressing* (p. 6), *The Window* (p. 14), *Alice* (p. 50), and *The Guitar Lesson*

(p. 9). The last-named creates a scandal. Works on design and costumes of Shakespeare's *As You Like It* for Victor Barnovski. Meets Antonin Artaud and makes friends with Giacometti.

1935 Designs set and costumes for Artaud's *The Cenci*. Paints the portrait of *Lady Abdy* (p. 15), and the self-portrait *The King of Cats* (p. 30).

PAGE 92:
TOP: Baladine Klossowska, Balthus and Rainer Maria Rilke at Beatenberg, summer of 1922

RIGHT: *Antonin Artaud*, 1935
Indian ink, 24 x 20.5 cm
Private collection

BOTTOM: Lady Abdy and Antonin Artaud in *Les Cenci*, 1935

PAGE 93:
RIGHT: *Alberto Giacometti*, 1950
Pencil on squared paper, 21.5 x 16.5 cm
Private collection

BOTTOM: Picasso and Balthus, photographed by Cecil Beaton, late 40s

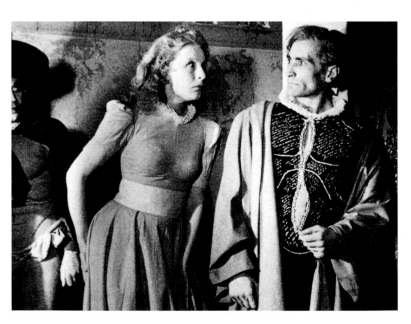

Paints *The Victim* (p. 65) and *The Blanchard Children* (p. 20), which Picasso buys from him in 1942. *Street* enters the collection of James Thrall Soby.

1938 First exhibition at the Pierre Matisse Gallery in New York. Paints *Young Girl with a Cat* (p. 34), *Thérèse Dreaming* (p. 33) and the double portrait *Joan Miró and his Daughter Dolores* (p. 17).

1939 Paints *Larchant* (p. 23). He is mobilised, sent to Alsace, then discharged in December after being wounded.

1940–1941 After the invasion of the *zone libre* of France, he takes refuge with Antoinette in Savoy, then in Aix-les-Bains, at the Champrovent farm where he had stayed with his friends the Leiris in the late 1930s. Begins *Champrovent Landscape* (p. 22), and the several versions of *The Living Room* (p. 42). Paints *Girl on a White Horse* (p. 52).

1942–1943 Moves to Berne, then Fribourg. Birth of his son Stanislas. Exhibition at the Moos Gallery in Geneva.

1944 Birth of his son Thadée.

1945 Moves to the Villa Diodati, at Cologny, near Geneva. Becomes friendly with the publisher Albert Skira, meets André Malraux. Finishes *Happy Days* (p. 55).

1946 Returns to Paris. Exhibition at the galerie Beaux-Arts organised by Henriette Gomès.

1947 Travels to the South of France with André Masson, and meets Jacques Lacan, Sylvia Bataille, Picasso and Françoise Gilot.

1948 Designs set and costumes for Albert Camus's *L'État de Siège*. Paints a series of nudes, including *The Room* (p. 60), and begins *The Game of Cards* (p. 21).

1949 Paints *The Méditerranée's Cat* (p. 32) and *Georgette Dressing* (p. 58). Death of his father Erich Klossowksi at Sanary.

1950 Designs set and costumes for the Festival d'Aix-en-Provence production of Mozart's *Cosí fan tutte*.

1951 Stay in Italy.

1952 Begins *The Passage du Commerce-Saint-André* (p. 12) and *The Room* (p. 38).

1953 Moves to the château de Chassy in the Morvan region. Designs set and costumes for Ugo Betti's *Crime on Goat Island*.

1954 A consortium of collectors and dealers is created, which buys his entire production. Paints views of Chassy, portraits of Frédérique Tison and begins the *Three Sisters* series (p. 43).

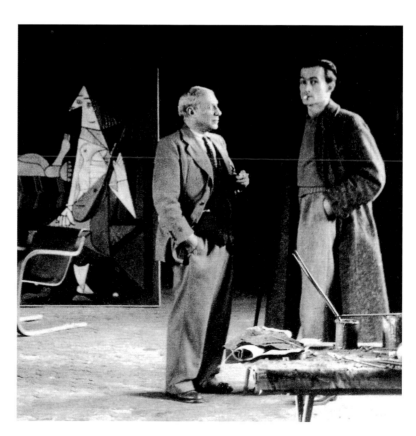

1955 Paints *Patience* (p. 39), *Nude Before a Mirror* (p. 61), *Dream I* (p. 66), and *The Triangular Field* (p. 24).

1956 Exhibition at the Museum of Modern Art, New York. Paints *The Golden Fruit* (p. 67).

1957 *Toilette* (p. 71), *Getting Out of the Bath* (p. 73), *Blue Cloth* (p. 72) and *Young Girl at the Window* (p. 28).

1959–1960 Set designer for Jean-Louis Barrault's production of Shakespeare's *Julius Caesar*. *The Moth* (p. 79), *Cup of Coffee* (p. 29), *Farmyard at Chassy* (p. 25).

1961 André Malraux, Minister of Culture to General de Gaulle, appoints Balthus Director of the French Academy in Rome at the Villa Medici. He undertakes the restoration of the building and reforms the teaching.

1962 Sent by Malraux to Japan to organise exhibitions of French painting, meets Setsuko Ideta.

1963 Setsuko poses for *The Turkish Room* (pp. 84/85).

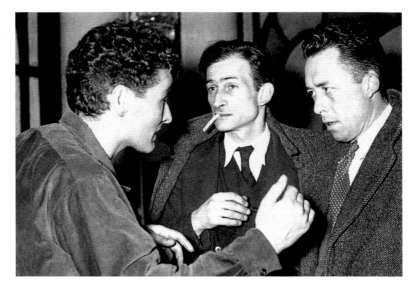

1964–1966 Continues as Director of the Villa Medici while working on his series of *Three Sisters*. In 1966, retrospective at the Musée des Arts décoratifs in Paris.

1967 Marries Setsuko Ideta, who poses for *Japanese Woman with Black Mirror* (pp. 82/83) and *Japanese Woman with Red Table* (pp. 84/85).

1968 Retrospective at the Tate Gallery, London. Begins *Katia Reading* (p. 59).

1969 Baladine Klossowska dies in Paris.

1969–1971 With an assistant, photographs Katia and her younger sister Michelina, so that painting of their portraits can proceed in their absence.

1973 Birth of his daughter Harumi.

1973–1977 *Nude in Profile* (p. 2), *Resting Nude* (p. 62).

PAGE 94:
TOP: Jean-Louis Barrault, Balthus, and Albert Camus, during a rehearsal of Camus's *L'État de Siège* (set and costumes by Balthus) at the Théâtre Marigny in 1948

LEFT: Balthus and Federico Fellini at the Grand Chalet, Rossinière

PAGE 95:
AT TOP, LEFT: Balthus and Setsuko at the Grand Chalet, in 1996: "You might have mistaken it for an old Japanese house…"

AT TOP, RIGHT: Balthus and Setsuko, photographed by Kishin Shinoyama

BOTTOM: Balthus, Setsuko and their daughter, Harumi, photographed by Henri Cartier-Bresson, 1990

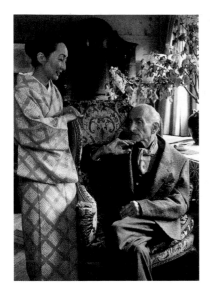

1983 *Nude in the Mirror* (p. 75).

1983–1984 Retrospective at the Musée National d'Art Moderne – Centre Georges Pompidou, in Paris, at the Metropolitan Museum of Art, New York, and at the Municipal Museum, Kyoto, Japan.

1987–1994 *Cat with Mirror II* (p. 47), *Cat with Mirror III* (pp. 48 and 49). In 1991, put forward by Jacques Chirac, Balthus wins the Praemium Imperiale awarded in Japan by the Japan Art Association. Retrospective at the Musée Cantonal des Beaux-Arts in Lausanne.

1998 University of Wrocław awards him an honorary Doctorate.

1977 Leaves Rome for Rossinière, Switzerland.

1975–1980 *Getting Up* (p. 40), *Cat in the Mirror I* (p. 44), *Sleeping Nude* (p. 77). Twenty-six paintings are exhibited at the Venice Biennale.

1980–1981 *The Painter and His Model* (p. 78).

2001 Balthus finishes his last painting, *Expectation* (p. 87). Dies at Rossinière on 18 February.

Cat Toasting a Grotesque Figure that Sticks Out Its Tongue, 1949–1952
Pencil on a fragment of tablecloth from the *Le Catalan* restaurant, 21.5 x 25 cm
Private collection

Acknowledgements and photocredits

The author and publisher would like to express their immense gratitude to Countess Setsuko Klossowska de Rola for her invaluable assistance and for her contribution to the understanding of Balthus's work.

They would also like to thank the museums, archives and photographers who have authorised the reproduction of works illustrated here and kindly assisted us in the creation of this book.

In addition to those persons and institutions cited in the captions, the following should also be mentioned:

Indiana University Art Museum, Bloomington, © 2002 photograph: 14; The Museum of Modern Art / SCALA, Florence, DIGITAL IMAGE © 2003: 10/11, 16, 17, 42; Magnum / Focus, Hamburg, © Henri Cartier-Bresson: 95; Wadsworth Atheneum Museum of Art, Hartford, © photograph Joseph Szaszfai: 27; Courtesy Galerie Alice Pauli, Lausanne: 74, 75; Christie's Images, London, © 2003: 71; Sotheby's Picture Library, London: 15; The Bridgeman Art Library, London: 30, 34, 38, 59, 67, 84/85; Museo Thyssen-Bornemisza, Madrid: 25; National Gallery of Victoria, Melbourne: 37;

The Metropolitan Museum of Art, New York: 1982 (1982.530) photograph © 1986: 18/19; 1998 (1999.363.2) photograph by Malcom Varon. Photograph © 1988: 33; 1987 (1987.125.2) photograph © 1993: 56; 1975 (1975.1.155) photograph © 1981: 61; RMN Paris, © photo: 8, 20, CNAC/MNAM: 6, 25, 79, 80/81, J. G. Berizzi: 20, C. Jean: 26, Philippe Migeat: 50; Washington, Hirshhorn Museum and Sculpture Garden, Smithsonian Institution, © photograph Lee Stalsworth: 55, 60; Artothek, Weilheim, Peter Willi: 62, 66; Courtesy Thomas Ammann Fine Art, Zurich: 13, 32, 43, 47, 48, 49.